User needs by
Systematic
Elaboration (USE)

Wim Heijs

User needs by Systematic Elaboration (USE)

A theory-based method for user needs analysis, programming and evaluation

 Springer

Wim Heijs
Department of the Built Environment, Real
Estate and Urban Development Group
Eindhoven University of Technology
Eindhoven, The Netherlands

ISBN 978-3-031-02054-4 ISBN 978-3-031-02052-0 (eBook)
https://doi.org/10.1007/978-3-031-02052-0

This Springer imprint is published by the registered company Springer Nature Switzerland AG
The registered company address is: Gewerbestrasse 11, 6330 Cham, Switzerland

Contents

Chapter 1
Introduction

Abstract The design of a building can facilitate the process of use and promote the well-being of its users if it meets their needs. Knowledge of the needs of users and the process of use seems important for a good design. However, it is not self-evident what these user needs really are, how user needs and processes of use can be researched, and how that knowledge can be used to improve a design. This book introduces a theory-based method for the analysis of user needs and processes of use, and for the application of the results in programs for building design and in building management. The first chapter contains an introduction to this topic. It discusses the context and the reasons why it needs (more) attention. After this, the purpose and structure of the book are explained.

Keywords User needs analysis · Process of use · Programming · Building design · Post occupancy evaluation · Failure costs

1.1 Context and Motivation

We are usually not aware that a large part of our environment consists of objects that are designed. This includes buildings, infrastructure, utensils and sometimes seemingly natural phenomena such as landscapes, rivers or woods. Mostly, the fact that these objects are designed is not obvious when they look and perform as expected. Occasionally, a design is more conspicuous, especially if it is exceptionally beautiful or ingenious, or, on the other hand, if design decisions have been made that interfere with the expected appearance or process of use. The latter will not necessarily be a problem. Shortcomings are, to a certain extent, tolerable and people can adapt to suboptimal conditions. Nonetheless, as shown by the following examples, design decisions can have consequences that are more serious.

Case 1. Government office building

After a major renovation, the office building at Rijnstraat 8 in The Hague was reopened in 2017 to accommodate 6000 employees of 3 ministries of the Dutch government (Fig. 1.1). For reasons of efficiency and of cost reduction, a choice was made for open spaces with 4400 multifunctional and flexible workplaces (about 3200

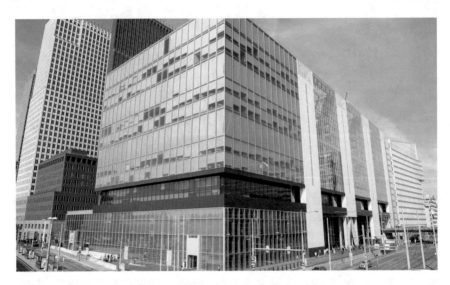

Fig. 1.1 Government office building Rijnstraat 8 (Ministerie BZ 2017)

desks and various other spaces, such as meeting rooms, concentration zones and open areas for social interaction). After the building was occupied, a number of problems emerged. According to the evaluation report by Beijer et al. (2018), there appears to be a lack of workplaces: often employees cannot find a place that fits their activities, and when they leave the place for some time, they are inclined to claim it using territorial markers. The building is very crowded with queues at the entrance, toilets and lifts. The tight positioning of workplaces, movements, the noise and the absence of acoustic barriers interfere with the need for concentration and for privacy during meetings or phone calls. The building has an impersonal character both inside and out. Floors and corridors look similar and signs are often absent or hard to read so that wayfinding can be difficult. These and other problems (with furniture, indoor climate, cleaning and means of locating colleagues) cause feelings of uneasiness and tiredness among employees and reduce job satisfaction, cooperation and productivity. According to a later audit, the fact that users were not involved in the project (in time) is a major cause of the problems (Auditdienst 2019).

Case 2. City district

In the second half of the 1960s, the city of Amsterdam tried to counteract the housing shortage by building a new district in the Bijlmermeerpolder. The project was based on the modernist ideas of urban design, with strict separation of functions like working, living, recreation and traffic. High-rise blocks provided housing for 40,000 families and large green areas in between were meant for recreation (Fig. 1.2). Elevated roads and parking garages, connected to the blocks by covered walkways, separated cars from bikes and pedestrians on the ground level. This should enhance the well-being of residents with respect to safety and clean air. However, these ideas

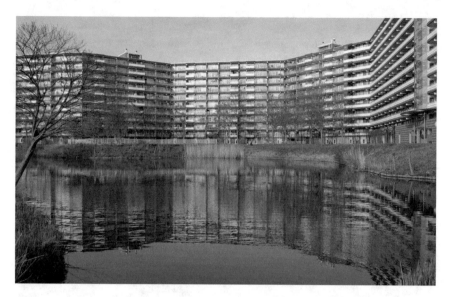

Fig. 1.2 Bijlmermeer high-rise (Janericloebe 2010)

did not work out well (Mentzel 1989; Mingle et al. 2019). The large dwellings were meant to attract middle-class families, but those families preferred detached houses with a garden, the advantage of parking the car near their front door, and more services and shops. As a result, the Bijlmermeer had a high vacancy rate. Rather soon, dwellings were rented out to lower income groups or they were occupied by squatters and illegal immigrants. The number of unemployed rose and the crime rate increased. Due to a lack of social control in the green areas and walkways, loitering teens and junks caused much nuisance. Buildings and public spaces showed signs of vandalism and dilapidation, and there were strong feelings of insecurity. To turn the tide, a huge investment was necessary. High-rise blocks were torn down, functions and traffic modes were mixed again and the amount of services was increased. Currently, the district has regained certain livability.

Case 3. Warning light

In 1979, there was a partial meltdown of one of the reactors in the Three Mile Island Nuclear Generating Station near Harrisburg (Fig. 1.3). This resulted in the leak of radioactive gases and iodine into the environment (Wikipedia 2019). At first, there were problems in the mechanical system during the cleaning of the water filters. Accidentally a valve stayed open that should have been closed, which led to a considerable leakage of nuclear reactor coolant. As a result, the core partially disintegrated. The operators could have dealt with this situation properly if they would have had the correct information. However, a warning light, that should have been on to show that the valve was open, stayed dark, implying that the valve was closed. Actually, the light did not indicate the position of the valve but the power

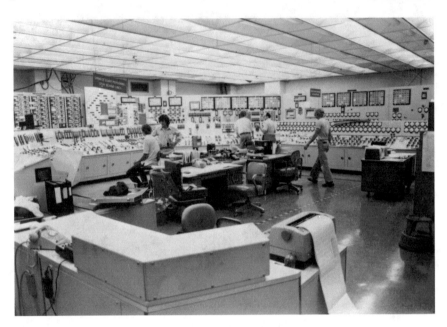

Fig. 1.3 Three Mile Island control room in 1979 (NRC 2012)

status of the solenoid attached to the valve. The operators were not aware of this ambiguity in the indicator panel and thus of the possibility that the valve might still be open. Consequently, the leakage of coolant was not detected in time. This flaw in the user interface of the power plant, and an insufficient training of the operators, led to serious ecological and health risks and increased concerns about nuclear energy. The cleaning process lasted until 1993 and took about one billion dollars.

These examples show that situations in which a design has an undesirable effect can be quite diverse. This does not only concern old cases, but also more recent ones, and they can involve very different kinds of objects and scale levels (buildings, neighborhoods or user interfaces). The effects can be diverse as well. There may be *functional* consequences for the process of use (e.g. the efficiency of work), or *physical* influences on one's health (radioactive gas), the use of senses (loud noises) or movements (standing in queues). *Social* effects can be revealed, for example, by problems with privacy and with social interaction. *Psychological* influences can become manifest on a cognitive level (e.g. problems with wayfinding or problem solving) or as emotions (such as feelings of insecurity). This can result in dissatisfaction and a reduced mental well-being. In addition, there can be *economic* consequences. These mainly consist of so-called failure costs, which are expenses for improving the design and object or for repairing the possible damage. There may also be legal costs related to claims, and losses because of reputational damage. Failure costs are likely to exceed additional investments at an earlier stage to prevent these problems.

The examples also show that these situations can be very complex. There are several parties involved, each with their specific contribution, and the context plays an important role. The problems at Rijnstraat 8 are to some extent attributable to choices made by the government. The population in the Bijlmermeer could have been different if there had been less detached houses in the surroundings, so that middle-class families would have been more likely to choose the Bijlmermeer as their residence. Also, a suitable training of the operators might have prevented the nuclear accident. The problems can therefore not be attributed to the design alone. It is evident, however, that deficiencies in the design can have an important impact.

It seems that in a design sometimes too little account is taken of the users of the object in question and of the interaction between the object and its users. Possible reasons for this lack of attention, in relation to buildings, are discussed by, among others, Sommer (1983), Zeisel (1984), Norman (1988), Popov (2002), Sanoff (2003) and Gifford (2007). First, there are architectural styles that assign no or only a marginal role to the users (e.g. formalism, modernism). Buildings are seen as works of art with the focus on aesthetic shapes and structures, materials and construction rather than utilization or user needs. The recognition of architects is attached to the former aspects. Similar opinions also sometimes characterize courses in architecture. As a result, these architects can have a lesser understanding of the possible problems of users. In addition, users can play a minor role when designers work for paying clients (e.g. developers or governments). In that case, the users may be unknown and there can be other priorities, such as building and maintenance costs (see case 1). Furthermore, users can be excluded if designers rely on their own expertise or on their own experience as a user. They may think that the input of users as laypersons has limited added value. Sometimes, the input of users is even seen as a threat to creativity (Heijs 2007). Insufficient exchange of information between designers and paying clients on the one hand and using clients on the other is referred to as the *user-needs gap* and the *client-client* gap respectively (Bell, Greene, Fisher and Baum, 2001).

Conversely, many designers recognize the importance of the functionality of buildings and a proper interaction between buildings and their users. In the past decades, this has become more important in the field of the built environment. Improvement of the interaction is pursued, for example, by involving users more in the design process (see Chap. 2). The striving for a proper interaction requires knowledge of, among other things, user needs and aspects of the environment that influence the functionality of a design and the quality of the interaction. In addition, designers must have appropriate methods at their disposal to study this, to promote the process of involvement and to apply the information in a design. This calls for an extensive cooperation between design disciplines and the social sciences. However, there seems to be an *application gap* between these fields (Bell et al. 2001). This implies a lack of communication and unfamiliarity with each other's data and methods. Judging from the more recent examples of less fortunate design decisions, that gap probably still exists.

1.2 Purpose and Structure

This book tries to contribute to closing the application gap from the field of environmental psychology that has ties with the design disciplines. The focus is on a method to carry out user needs analyses, create programs of demands and perform post occupancy evaluations, and on the theoretical perspective and the conceptual framework that underlie the method. This approach is called USE (User needs by Systematic Elaboration) because it concerns the elaboration of user needs and related demands for a proper interaction in a series of methodical steps.[1]

The perspective and conceptual framework are described in Chap. 3. It contains the line of reasoning and the guiding principles of the method. The method is explained in Chaps. 4 and 5. The main purpose is to translate the interaction between buildings and their users in a program of demands for a design that attempts to prevent adverse effects and failure costs. It builds on methods in social design (see Sect. 2.2.1) and adds several new elements. These chapters take the form of a manual for the practical application of the method. The perspective and method are preceded by a description of the disciplinary and methodological background in Chap. 2. The method has been developed in the Real Estate Management and Development group of the University of Technology in Eindhoven. It was part of the curriculum and it was used in contract research and graduation projects. Some of these studies are discussed in Chap. 5 to show how the method can be adapted to specific conditions and situations. The final chapter offers a review, which includes a comparison with other methods and an outline of possible future developments. The book as a whole can be used as a basis for lectures on this subject. It has three appendices. The first contains the instruments for the practical application of the method, the second consists of questions and assignments related to each chapter, and the third provides some thoughts on the possible implementation in a renovation process of problem neighborhoods.

The target group of the book comprises all those who are interested in the creation of environments for people (users, designers, policymakers, real estate managers; students and scientific staff). The accent is on buildings, but the subject matter may also apply to other objects of design (ranging from utensils to outdoor spaces).[2] The interaction between buildings and users may further improve if the essential knowledge and abilities do not only originate from the cooperation of designers with social scientists but belong to the expertise of designers themselves as well. This can promote the awareness of the possibilities and benefits of user-oriented research in that occupational group. Thus, designers are a special audience, for whom the book may serve as a guide and a starting point for relevant theoretical and methodological background information.

[1] The name is derived from the original purpose of the method to perform user needs analyses. Later, drawing up of programs of demands and carrying out post occupancy evaluations were added. The name has not been changed because the conceptualization of user needs remained a distinguishing feature which also determines the view on interaction (see Chap. 3).

[2] In most cases, if the terms 'building' and 'location' (in a building) are used in this book, they can be replaced by 'object' or 'part' (of an object).

To end with, the perspective and the method explicitly take account of the creative freedom of designers. User needs analyses, programs of demands and post occupancy evaluations do not pose a threat but rather a challenge to creativity. They serve to make user needs and related characteristics of the environment visible, so the designer can find appropriate solutions for complex situations. This is in agreement with Sommer's (1983) statement that social design can be regarded "as an invitation to a greater rather than a lesser vision of architecture".

References

Auditdienst (2019) Onderzoeksrapport Audit Rijnstraat 8. Research report. Auditdienst Rijk, Den Haag

Beijer M, Colenberg S, den Hollander D, Cox H, Smid E, Pullen W (2018) Rijkskantoor Rijnstraat 8. Gebruik en beleving geëvalueerd. Report. Center for People and Buildings, Delft

Bell P, Greene T, Fisher J, Baum A (2001) Environmental psychology, 5th edn. Harcourt CollE, Fort Worth

Gifford R (2007) Environmental psychology: principles and practice, 4th edn. Optimal Books, Colville, WA

Heijs W (2007) User needs analysis and bridging the application gap. In: Edgerton E, Romice O, Spencer C (eds) Environmental psychology: putting research into practice. Cambridge Scholars Publishing, Newcastle, pp 30–43

Janericloebe (2010) Amsterdam Zuidoost, Flat Hakfort. Author: Janericloebe. https://nl.wikipedia.org/wiki/Bestand:Amsterdam_Zuidoost_Flat_Hakfort_001.JPG. Accessed 26 Aug. 2019. License: idem

Mentzel M (1989) Bijlmermeer als grensverleggend ideaal. Dissertation. TU Delft, Delft

Ministerie BZ (2017) 170828 Gebouw BZ 7841. Aad Meijer, Author. https://www.flickr.com/photos/ministeriebz/36492101180. Accessed 26 Aug 2019. License: https://creativecommons.org/licenses/by-sa/2.0/

Mingle K, Bajema C, Hemel Z, Dekker D, de Bruijn P (2019) Episode 296. Bijlmer (City of the Future, Part 1). https://99percentinvisible.org/episode/bijlmer-city-future-part-1/. Accessed 26 Aug 2019. Episode 297. Blood, Sweat & Tears (City of the Future, Part 2). https://99percentinvisible.org/episode/blood-sweat-tears-city-future-part-2/. Accessed 26 Aug 2019

Norman D (1988) The psychology of everyday things. Basic Books, New York

NRC (2012) TMI-2 control room in 1979. https://www.flickr.com/photos/nrcgov/7447591424. Accessed 18 Sept 2021. License: https://creativecommons.org/licenses/by-nc-nd/2.0/

Popov L (2002) Architecture as social design. The social nature of design objects and the implications for the profession. J Des Res 2:105–120. www.inderscience.com

Sanoff H (2003) Including users benefits all: the value of participatory programming. www.researchdesignconnections.com

Sommer R (1983) Social design: creating buildings with people in mind. Prentice-Hall, Englewood Cliffs, NJ

Wikipedia (2019) Three Mile Island accident. https://en.wikipedia.org/wiki/Three_Mile_Island_accident. Accessed 26 Aug 2019

Zeisel J (1984) Inquiry by design: tools for environment-behavior research. Cambridge University Press, Cambridge

Chapter 2
Disciplinary and Methodological Background

Abstract The purpose of USE is to improve the interaction between users and their environment by enabling more appropriate design decisions. This chapter discusses the disciplinary and methodological background of the method and the way the principle of interaction is embedded in it. An important means to reach this goal is the involvement of the users in the process of programming and design. A description is given of various approaches to user involvement.

Keywords Person-environment fit · Social design · Participatory design · Building performance evaluation · Performance based building · User centered design

2.1 Disciplinary Background

Interaction between users and the physical environment is a central theme in environmental psychology. Gifford (2018) defines this discipline as the study of 'how we, as individuals and as group members, interact with our physical settings (man-made and natural), how we experience and change the environment, and how behavior and experiences are changed by that environment'. To properly analyze certain situations, it may be advisable to include not only the participating entities and their interaction but also the broader context and the process over time, and to consider it a holistic system. This is referred to as a transactional perspective.

In environmental psychological research and theory, the interaction and transaction processes appear in different forms. In this section, a number of these forms are described to provide a feeling for and more insight in the various ways the interaction between users and the built environment can be analyzed and understood. It is also shown how those insights may sometimes be used to derive design decisions or rules (like the method in the next chapters). In addition, these descriptions can familiarize readers who have another background with some relevant psychological terms.[1]

[1] Parts of Sect. 2.1 are adapted from a book chapter (see Heijs 2006).

W. Heijs, *User needs by Systematic Elaboration (USE)*,
https://doi.org/10.1007/978-3-031-02052-0_2

2.1.1 *Information Processing*

The first example of interaction explained here is information processing, because it
is basic to nearly every other type of interaction. Actually, it is a special case because
it mainly resides on the user side. Nevertheless, the process takes input from the
user and from the environment and generates output to both. Figure 2.1 depicts a
model of information processing with its components and the relations with the built
environment and the users.

Sensation is assumed to be the starting point, although this is somewhat arbitrary
because the process is cyclical. It refers to the input of stimuli through the sensory
organs (e.g. visual, auditory, olfactory). Since users are constantly receiving large
amounts of sensory input, it is necessary to select the relevant information and to
synthesize what is left in a mental image for further processing. This routine is called
perception.[2] Then the mental image has to be recognized in order to be usable as an
impulse for behavior and often it must also be related to an emotion to determine
the direction of behavior. In *cognitive interpretation* and *affective evaluation*, cogni-
tive and emotional labels are assigned to the image by associating it with existing
knowledge. Between this stage and *actual behavior* several mechanisms are assumed
to operate, indicated by concepts like *attitude, habit, perceived control, subjective
norms, intention and planning*, which are not explained here. Behavior, in turn, is
followed by new sensations.

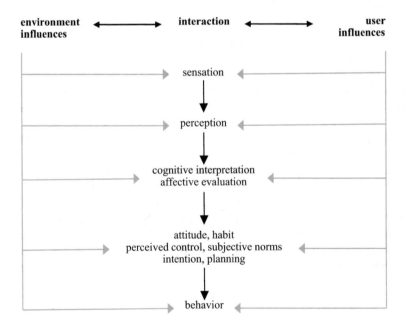

Fig. 2.1 General model of information processing (adapted from Heijs 2006)

[2] Perception and cognition have a long history and their definitions have changed often. It should
be stressed that the diagram is intended as a heuristic and does not pretend to be comprehensive.

All stages in the process are influenced by characteristics of the user and of the environment. This is illustrated by the gray arrows moving inward. These influences can serve to analyze problems and derive guidelines for design. Using case 3 in the introduction as an example, Table 2.1 depicts the nature of fictional influences

Table 2.1 Influences of environment and user, guidelines (adapted from Heijs 2006)

1. Sensation	
Environment	The light is not clearly visible
User	Users do not notice the light
Rule	Design elements necessary for behavior must be visible, while unnecessary or distracting elements should be hidden
Other	e.g. relevant video controls are conspicuous, others behind a panel
2. Perception	
Environment	The light is overlooked because it does not stand out against the panel
User	The user can not construct a mental image of something that is useful
Rule	Design elements must evoke mental images that are unambiguous, attracting attention and accurate (corresponding to the intended use)
Other	e.g. a doorknob that looks like a separate object that is usable
3. Cognition	
Environment	There is no instruction or clue about what the light means
User	It is not known as something that is intended for operators
Rule	Design elements must, if necessary, give information about their use or the consequences (feedback) by referring to present knowledge
Other	e.g. wayfinding symbols that are familiar to users
4. Affection	
Environment	The light has a bright color to alert users
User	Operators feel that they should hurry to act on the light
Rule	Design elements should evoke emotional responses that match the desired behavior and be neutral if no particular behavior is expected
Other	e.g. a trashcan that looks attractive and comfortable to use
5. Intermediate	
Environment	The appropriate reaction to the light is within the control of the user
User	The light promotes the readiness to act
Rule	Design elements must evoke the proper attitudes and behavioral intentions, and allow a correct estimate of the amount of control
Other	e.g. an emergency exit that is not uninviting, a private door that is
6. Behavior	
Environment	Responding to the light requires a special switch that is available
User	Operators have the capabilities to respond to the light
Rule	Design elements must make clear that the intended behavior is the best alternative while unwanted behavior must be or seem impossible
Other	e.g. a park bench enclosed by a fence when it is a work of art

from the environment and the user in the different stages, and examples of design guidelines that may be inferred, together with a possible application of these rules in a different context.

In reality, of course, matters are much more complex. Subprocesses share feed-forward or feedback loops. Cognition, for instance, steers perception, because experience influences the selection processes. Knowledge will be extended with mental models of the environment and causal relationships that are learned or inferred from behavioral effects (e.g. cognitive maps in wayfinding or lay theories).[3] There are many influential variables on both sides, such as characteristics of the social or physical context, and needs, abilities and structural variables. These variables can also have a bearing on each other (e.g. social contacts that affect problem solving abilities).

2.1.2 *Affordances*

A concept with special relevance is 'affordance' (Gibson 1979; Norman 1988). Affordances are action possibilities of objects in the environment (i.e. inviting a certain use) based on physical properties of those objects.[4] Affordances are perceived earlier than the separate properties themselves. They steer behavior directly, without mediation of cognition or affective evaluation (in Fig. 2.1, they would follow perception with a direct link to behavior). A door, for instance, can be perceived as 'pull-able' or 'push-able', thus inviting a specific behavior without a conscious elaboration of the properties leading to that reaction. This perception may depend on the background and the culture of the persons involved.

Affordances are not subjective: they are real and invariant (not depending on temporary states). They are not objectively measurable either, whereas the properties of the object are. Affordances exist in the presence of both objects *and* users as a result of their interaction on a perceptual level. An understanding of affordances of design objects, and of the properties that constitute them for a certain user group, can be utilized to steer behavior and prevent problems concerning their usability. The fact that affordances operate on a pre-cognitive level implies that it is usually not adequate to evaluate the effects verbally, for instance with interviews or by obtaining feedback from users; observational methods are indicated.

[3] These theories are made up by laypersons as an intuitive explanation of certain phenomena. A well-known example is the valve theory of thermostats (Kempton 1986). According to this lay theory, a thermostat works like a valve to control the amount of heat, so it triggers that type of usage.

[4] Norman's (1988) definition of the concept differs from that of Gibson (1979). The latter focuses on the actual action possibilities in the environment while the former also includes the perception of these action possibilities. The description in this section is closer to Norman's view. There has been much discussion on the difference but that is beyond the scope of the book. Interested readers are referred to Soegaard (2019) or Kaptelinin (2019).

2.1.3 Mapping

The concept of 'mapping', as introduced by Norman (1988), refers to the corre-
spondence between the possibilities to act, suggested by the design, and the effects
of those actions. These should match to promote a proper interaction and prevent
unwanted use, bad experiences or even accidents. Mapping is used in cognitive
interpretation and subsequent processes in Fig. 2.1. The appearance and the func-
tion of appliances, for example, should conform to the expected functionality and
experience with similar devices. To illustrate, an inappropriate mapping between the
position of burners on a cooking-range and their controls might lead to burned food.
Another example is the design of a turning knob that controls the output volume.
This requires attention because the direction of rotation depends on the output and
is not self-evident: increasing the output in the case of sound, for example, implies
turning it clockwise, but in the case of water it should be turned counterclockwise.
If the effect of such a turning knob is unclear in a nuclear facility, the results can
be disastrous. Sometimes, it is possible to apply a spatial layout of the controls or
known symbols to achieve a form of self-evident interaction. This is called natural
mapping.

2.1.4 Person-Environment Fit and Congruence

Person-environment fit and congruence are related concepts that refer to the corre-
spondence between characteristics of the users and properties of their environment.
P-E fit is rooted in organizational psychology (Kristof 1996; Ostroff 2012) and in
environmental psychology, predominantly in gerontology research (Cvitkovich and
Wister 2001; Lien 2013).[5] There are several approaches and models. A first distinc-
tion that can be made is between supplementary and complementary fit (Kristof
1996; Cable and Edwards 2004; Edwards and Shipp 2007). *Supplementary fit* relates
to corresponding qualities of users and the environment (e.g. similar values or goals
of employees and an organization). *Complementary fit* concerns the mutual comple-
mentation of characteristics of users and environment. Within this approach, two
main models can be identified. According to the *competence model*, P-E fit is the fit
between individual competences/abilities and environmental demands, for example
between the physical capacities of users and the activities that the environment (an
organization or a building) requires (Lawton and Nahemow 1973; Lien 2013). In the
congruence model, it is the fit between needs of users and environmental resources to

[5] The field theory of Lewin (1950) and the need-press model of Murray (1938) are mentioned as the
actual origins. In short, the field theory holds that behavior is a function of the interaction between
a person and the overall environment in which a person functions. According to the need-press
model, behavior is initiated from personal needs. Needs and behavior are affected by various forms
of press (environmental factors), including alpha press (real influences) and beta press (perceived
influences).

provide for these needs (Kahana 1982; Carp and Carp 1984; Kristof 1996; Cvitkovich and Wister 2001; Cable and Edwards 2004; Edwards and Shipp 2007; Lien 2013). An example is the extent to which the number of rooms in a house fits the need for privacy of the residents. In Fig. 2.1, P-E fit can be placed where the influences of environments and users meet (the gray arrows) in the latter three stages.

P-E fit (supplementary or complementary between abilities and demands or between needs and resources) is a major determinant of the quality of the interaction process between the users and the environment. Generally, better P-E fit is linked to more appropriate behavior (e.g. productivity in an organization or processes of use in a building), more satisfaction and well-being of users (Cvitkovich and Wister 2001; Kahana et al. 2003; Cable and Edwards 2004; Oswald et al. 2005; Ostroff 2012; Lien 2013). The effects are not only attributable to characteristics of the users (P) or the environment (E) but are also an explicit consequence of the degree of fit between the two (P × E). Because the circumstances are seldom ideal, the fit is usually less than optimal. If it is unacceptable, users can try to change their needs or abilities (to adapt to the environment) or try to modify environmental resources or demands. If that is ineffective or impossible due to personal or situational constraints, such a misfit may result in psychological strain, inappropriate behavior and less well-being.

Congruence is often used as a synonym for fit, especially between needs and resources. It can also have a slightly different meaning, namely the fit between environments and users from an *objective* or an *expert* point of view as opposed to the *subjective fit* perceived by users (Gifford 2017). An objective fit or expert standpoint can deviate from a subjective or user opinion. In the second case in the first chapter, for example, planners may believe that the design is congruent, while residents consider the livability as insufficient. Generally, subjective fit is a better predictor of well-being and of behavior than objective fit (Cvitkovich and Wister 2001; Kahana et al. 2003; Edwards and Shipp 2007).

2.2 Approaches and Methods Involving Users

A closer fit between the built environment and its users, and thus a better interaction, can be achieved by involving the users in the design process. USE is a form of user involvement. To illustrate methods that take more account of users, and to point out similarities and differences between the methods later, this section briefly describes some known examples: social and participatory design, building performance evaluation, performance based building and contemporary design methods in the field of product development.[6]

[6] Parts of Sect. 2.2 are adapted from a book chapter (see Heijs 2007).

2.2.1 Social Design and Participatory Design

Social and participatory design originate from environmental psychology and architecture. An important objective of social design is that, through collaboration of designers and social scientists with users, environments can be created that match the needs and activities of the users (Sommer 1983; Gifford 2017).[7] Social design is an umbrella term for methods of design that intend to "work with people rather than for them" (Sommer 1983). It can be contrasted with formal design. The latter can be typified as large scale, national, corporate, exclusive, high-tech, concerned with style, high cost, top-down and authoritarian, while the former tends to be small scale, local, human-oriented, inclusive, using suitable technologies, concerned with meaning, low cost, bottom-up and democratic. Research is important as a basis for design and for facilitating the communication between all participants in the design process. This results in more usable environments, more satisfaction and potential savings.

Participatory design belongs to social design. It covers various methods as well. In this context, the emphasis is on the approach of Sanoff (2000, 2003, 2016). In participatory design, a passive role of users of just being informants is replaced by their active involvement in programming and design in order to realize environments that are optimally suited to their needs. Because of this participation, users sense concern for their needs, which promotes satisfaction and trust, while designers become aware of the needs of users. Most projects relate to the design or the renovation of housing, educational facilities, community buildings and neighborhoods. All stakeholders should preferably be engaged in the process.

The procedure consists of four steps. The first step (goal setting) aims at the creation of awareness of the situation and the needs among users and designers. Next, the programming stage is intended to reach more mutual understanding and shared expectations, leading to the development of a common language and an account of the needs and goals. To accomplish these objectives there is a vast array of instruments, such as focus groups, lists (e.g. wishes, keep/change, do's and don'ts), charrettes, media, walk-throughs and games. The third step (design) consists of decision-making. The participants work on the program and the actual plan by suggesting and reviewing alternatives (e.g. using design kits). Designers supply the technical education that is needed and information on the consequences of decisions. In the last step, the design is implemented and, after some time, evaluated. This is an important phase because the participants must remain involved and assume responsibility for the outcome. Satisfaction does not only arise from participation but also from shared responsibility.

[7] Social design is, in a broader sense, regarded as a movement to bring about social reform by proper design and by stressing the social responsibility of designers and users.

2.2.2 *Building Performance Evaluation and Performance Based Building*

A building performance is an attribute that expresses how well a building performs a certain function. Building Performance Evaluation focuses on the evaluation of building performances in all phases of a building's life cycle (Preiser and Vischer 2005; Preiser et al. 2018). It is rooted in the fields of architecture and environmental psychology. The goal is to improve the quality of buildings and to accumulate knowledge for design and construction through the systematical comparison of actual performances of buildings to expected performances. These performances are redefined user needs on three different levels: technical (health, safety and security), functional (efficacy and efficiency) and behavioral (social, psychological, cultural and aesthetic).

BPE is often used for larger projects. It involves six phases, each with a feedback loop (added here in parentheses). The first phase is the *strategic planning*. This is an analysis of the market and the needs derived from the mission and goals of the organization (with a review of the efficiency of the planning). The next phase is *programming*, which offers an outline of the needs, aims and resources of the client and the context of the project (with a review of the performance criteria and other outcomes). The third phase is the *design*, starting with a schematic design and developing into construction documents (with a review of solutions and design decisions related to goals and requirements). The fourth phase is *construction* (with commissioning as a check to ensure that the contract is fulfilled and that performance criteria, standards and norms are observed). The fifth phase is *occupancy*. This extends over a longer period of time in which results of decisions made during earlier phases can be reviewed (with a regular post occupancy evaluation for feedback on the functionality, and advice on possible improvements; also see Chap. 3). The sixth phase is *re-use/recycling*, which serves to determine how a building adapts and can be recycled (with a market and needs analysis to evaluate the demand for that building type in terms of the needs of future clients). The end of this phase is also the start of the next building life cycle.

Performance based building is a method for programming and evaluating buildings which stems from facility and construction management. It has strong ties with environmental psychology. It emphasizes the ends rather than the means by describing what a building is required to do instead of prescribing how it should be constructed (Szigeti and Davis 1997, 2005; Zeegers and Ang 2003). The focus is on non-prescriptive directions for design, related to the activities and goals of users, instead of solutions or wants. The approach mainly deals with larger office buildings.

A performance based building process starts with the examination of the objectives of the users. These are translated into functional requirements, stating, in a non-delimiting way, how a building should perform to realize them (e.g. a clear routing for safety). The functional requirements (in user language) are then converted into performance requirements (in technical language) with measurable design criteria, which are still not prescriptive but reflect the ends (e.g. an exit is reachable within

5 min). There are several instruments for these steps, such as structured question-naires for identifying the workplace *requirements for functionality* (from the side of the users) and the *capabilities of the building* to meet those requirements (ASTM stan-dards for whole building functionality and serviceability).[8] A Statement of Require-ments (program) includes both sets of requirements and capabilities together with internal and external constraints (see Sect. 3.3). To ensure that the building meets the requirements and is well developed, the next steps consist, among other things, of a verification procedure and an evaluation of the results against the criteria (see Sect. 3.4). This improves the communication and cooperation between users and other stakeholders and increases user satisfaction and acceptability of the results.[9]

2.2.3 Design Concepts in Product Development

The fields of ergonomics and information technology already have a long history of research on the interaction of users with products and software. Insights and methods in these domains may be relevant for the interaction of users with the built environment. Thus, a short overview is provided of the main approaches.

In 1986, Norman introduced the concept of *user centered design*, a design process that is aimed at creating usable and understandable products and systems. User centered design assigns a central and active role to the user during product devel-opment with a constant focus on their characteristics, needs, interests, capabilities and intentions for using the product. It starts with research on user requirements, followed by prototyping (design) and empirical tests (evaluation research) in an iter-ative cycle with continuous refinement until the results meet the objectives (Kujala 2003; Massanari 2010; Ritter et al. 2014). Common methods are surveys, interviews, observation, task analysis, contextual inquiry, focus groups, simulation, role-play and usability testing. To confirm whether a product functions properly in the real world it is advised to continue evaluation research after its release (Abras et al. 2004).

Since the 1990s the term *human centered design* is used as a synonym for user centered design and later to emphasize that the focus should not only be on the direct interaction between the user and the system, but also on effects on human capabilities, characteristics and behavior in the broader situational and social context (Ritter et al. 2014). Thus, it developed into a mindset to humanize design and society, which is not unlike that of social design. It should be mentioned that there are various other definitions.

The concept of *user experience design* is relatively more recent. Norman suggested the term in 1993 to express that it was his intention to "cover all aspects of the person's

[8] ASTM stands for American Society for Testing and Materials.

[9] There are more methods in programming, pre-design planning and evaluation that involve users to a greater or lesser degree. It is not the intention of the book to provide a review of this field. Examples of other publications on the subject include Blyth and Worthington (2010), Peña and Parshall (2012), Hershberger (2015) and Fletcher and Satchwell (2019).

experience with a system, including industrial design, graphics, the interface, the physical interaction and the manual" (UX design 2019). The major difference with other approaches is that it takes more aspects into account to create new experiences: the person's emotions, beliefs, preferences, perceptions, physical and psychological responses, behaviors and accomplishments that occur before, during and after use. Experience is influenced by the system, the user and the context (Ritter et al. 2014). Research is mostly multidisciplinary and the phases are similar to those in user centered design. A particular method is user modeling with so-called personas, archetypes that should help the designer to empathize with users and understand their interaction with the system (sometimes also applied in other approaches). However, personas may be reductive and take away the attention from the real users (Massanari 2010).

There are several other approaches, which are generally derivatives from concepts described earlier, such as *use centered design, activity centered design, process centered design, contextual design* or *service design* with varying inclusion of context elements (e.g. work situations and processes, specific activities, business processes or after-sales services).

In summary, environmental psychology and P-E fit models constitute the disciplinary background of USE, because of the theoretical insights in the interaction between users and environment. The methodological context consists of the ideas of social design and the methods that involve users to arrive at design decisions. Based on this information, the next chapter describes the approach in USE.

References

Abras C, Preece J, Maloney-Krichmar D (2004) User-centered design. In: Bainbridge W (ed) Encyclopedia of human-computer interaction. Sage Publications, Thousand Oaks, pp 763–768

Blyth A, Worthington J (2010) Managing the brief for better design. Routledge, New York

Cable D, Edwards J (2004) Complementary and supplementary fit: a theoretical and empirical integration. J Appl Psychol 89:822–834

Carp F, Carp A (1984) Complementary/congruence model of well being in mental health for the community elderly. In: Altman I, Lawton M, Wohlwill J (eds) Elderly people and the environment. Plenum, New York, pp 279–336

Cvitkovich Y, Wister A (2001) A comparison of four person–environment fit models applied to older adults. J Housing Elderly 14:1–25

Edwards J, Shipp A (2007) The relation between person-environment fit and outcomes: an integrative theoretical framework. In: Ostroff C, Judge T (eds) Perspectives on organizational fit. Taylor and Francis Group, pp 209–258

Fletcher P, Satchwell H (2019) Briefing: a practical guide to the RIBA plan of work 2013 Stages 7, 0 and 1. Riba Publishing, London

Gibson J (1979) The ecological approach to visual perception. Erlbaum, Hillsdale

Gifford R (2017) Applying social psychology to the environment. In: Gruman J, Schneider F, Coutts L (eds) Applied social psychology: understanding and addressing social and practical problems, 3rd edn. Sage, Los Angeles, pp 351–381

Gifford R (2018) Environmental psychology. Enhancing our world. http://optimalenvironments. com/wp-content/uploads/2018/02/Environmental-Psychology-Booklet.pdf. Accessed 20 Aug 2019

Heijs W (2006) Technology and behavior: contributions from environmental psychology. In: Verbeek P, Slob A (eds) User behavior and technology development: shaping sustainable relations between consumers and technologies. Springer, Dordrecht, pp 43–52

Heijs W (2007) User needs analysis and bridging the application gap. In: Edgerton E, Romice O, Spencer C (eds) Environmental psychology: putting research into practice. Cambridge Scholars Publishing, Newcastle, pp 30–43

Hershberger R (2015) Architectural programming and predesign manager. Routledge, London

Kahana E (1982) A congruence model of person-environment interaction. In: Lawton M, Windley P, Byerts T (eds) Aging and the environment: theoretical approaches. Springer, New York, pp 97–121

Kahana E, Lovegreen L, Kahana B, Kahana M (2003) Person, environment, and person-environment fit as influences on residential satisfaction of elders. Environ Behav 35:434–453

Kaptelinin V (2019) The encyclopedia of human-computer interaction, 2nd edn, Section 44, Affordances. https://www.interaction-design.org/literature/book/the-encyclopedia-of-human-computer-interaction-2nd-ed/affordances. Accessed 26 Aug 2019

Kempton W (1986) Two theories of home heat control. Cogn Sci 10:75–90

Kristof A (1996) Person-organization fit: an integrative review of its conceptualizations, measurement, and implications. Personnel Psychol 49:1–49

Kujala S (2003) User involvement: a review of the benefits and challenges. Behav Inf Technol 22:1–16

Lawton M, Nahemow L (1973) Ecology and the aging process. In: Eisdorfer C, Lawton M (eds) The psychology of adult development and aging. American Psychological Association, Washington, DC, pp 619–674

Lewin K (1950) Field theory in social science. Harper and Row, New York

Lien L (2013) Person-environment fit and adaptation: exploring the interaction between person and environment in older age. Dissertation. Oregon State University, Corvallis

Massanari A (2010) Designing for imaginary friends: information architecture, personas and the politics of user-centered design. New Media Soc 12:401–416

Murray H (1938) Explorations in personality. Oxford University Press, New York

Norman D (1986) Cognitive engineering. In: Norman D, Draper S (eds) User-centered system design: new perspectives on human–computer interaction. Lawrence Erlbaum Associates Inc., Hillsdale, NJ, pp 31–61

Norman D (1988) The psychology of everyday things. Basic Books, New York

Ostroff C (2012) Person-environment fit in organizational settings. In: Kozlowski S (ed) Oxford handbook of organizational psychology. Oxford University Press, Oxford, pp 373–408

Oswald F, Hieber A, Wahl H, Mollenkopf H (2005) Ageing and person–environment fit in different urban neighbourhoods. Eur J Ageing 2:88–97

Peña W, Parshall S (2012) Problem seeking: an architectural programming primer. Wiley, Hoboken, N.J.

Preiser W, Vischer J (2005) The evolution of building performance evaluation: an introduction. In: Preiser W, Vischer J (eds) Assessing building performance: methods and case studies. Elsevier Butterworth-Heinemann, Oxford, pp 3–13

Preiser W, Hardy A, Schramm U (2018) Building performance evaluation, 2nd edn. Springer International Publishing

Ritter F, Baxter G, Churchill E (2014) Foundations for designing user-centered systems. Springer, London

Sanoff H (2000) Community participation methods in design and planning. Wiley, New York

Sanoff H (2003) Including users benefits all: the value of participatory programming. www.researchdesignconnections.com

Sanoff H (2016) Integrating programming, evaluation and participation in design: a theory Z approach. Routledge, London

Soegaard M (2019) The glossary of human computer interaction, Section 5, Affordances. https://www.interaction-design.org/literature/book/the-glossary-of-human-computer-interaction/affordances. Accessed 26 Aug 2019

Sommer R (1983) Social design: creating buildings with people in mind. Prentice-Hall, Englewood Cliffs, NJ

Szigeti F, Davis G (1997) Functional programming and evaluation: from theory to practice. Keynote Paper for the 1997 Conference of the Environmental Design Research Association. International Centre for Facilities, Ottawa

Szigeti F, Davis G (2005) Performance based building: conceptual framework. Final Report. CIB (PeBBu) General Secretariat, Rotterdam

UX design (2019) UX design defined. http://uxdesign.com/ux-defined. Accessed 21 Sep 2019

Zeegers A, Ang K (2003) State of the art of performance based briefing. Final paper WP 2.2. Government Building Agency, Den Haag

Chapter 3
Perspective and Conceptual Framework

Abstract The main functions of the method are to carry out user needs analyses, to prepare programs of demands and to perform post occupancy evaluations. Existing methods in the previous chapter serve as the basis to discuss the possible complications and the perspectives of USE regarding the central concepts of user needs, demands and evaluation research. Subsequently, theoretical insights from the disciplinary background are used in defining the corresponding parts of the conceptual framework of USE.

Keywords User needs · Performances · Program of demands · Formal evaluation · Functional evaluation · Functional value

3.1 Functions of USE

The main functions of USE (user needs analysis, programming and post occupancy evaluation) can be illustrated by the design cycle (see Fig. 3.1). A project that involves users generally starts with programming research, which consists of a user needs analysis (UNA) that forms the basis for a program of demands (PoD). The program contains the guidelines for the design. A preliminary report is presented to the client (paying client and end-users) in the design review phase for discussion and a check against the user needs and the program. This leads to a fine-tuning of the design and the implementation of necessary changes. When the design has been approved and the building has been constructed and used for some time (after further adaptations and maintenance, which is denoted by the term management), a post occupancy evaluation (POE) is recommended. This is important, not only to correct shortcomings of this building but also to learn about possible avoidable design errors in other projects. During the programming and evaluation research, information on a variety of issues becomes available (theories, methods, user needs and groups, interaction processes, avoidable problems, best practices, etcetera). This knowledge can be used in future projects. It lends the process a cyclic character. The method can thus be used in the first and last phases (in programming and evaluation research). Input is generated for some of the other phases (e.g. design review, design, management during occupation) but as such these are beyond the scope of USE (see Sect. 4.2.3).

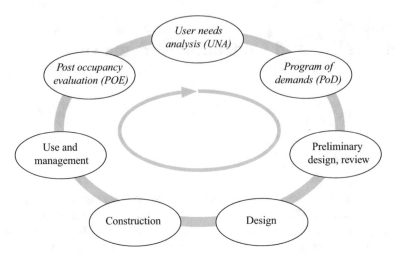

Fig. 3.1 Functions of USE in the design cycle

3.2 The Nature of User Needs

All previously described approaches to user involvement in design agree that knowledge about user needs is important and necessary for drawing up programs of demands. Then, the needs can serve as references during the design review and the post occupancy evaluation and as starting point for communication and negotiation between users, designers and paying clients. User needs can be inferred from theory, surveys among users, the participation process itself (through observations, interviews, discussions, workshops, etcetera) or the analysis of representative other settings if the users of the current project are not yet known.

3.2.1 Complications

Although the importance and necessity of knowledge about user needs is widely recognized, clear definitions, standard methods to establish these needs, well-documented overviews of needs, or information on the exact function or systematic application in a design process are mostly lacking. In addition, the descriptions and examples offered in the literature reveal substantial differences of opinion on what a user need is or how it can be conceptualized (see for instance the various sources in Sect. 2.2).

One view is that user needs refer to what people want, more in particular certain environmental elements or attributes that are seen as requirements for a satisfactory process of use and for well-being. Some examples from existing research are: specific materials, accessible offices, a diversity of spaces, energy-sensitive design, adjacency

of functionally related areas, parking spaces and also more vital issues such as the availability of food or shelter (Sommer 1983; Sanoff 2000; Hattis and Becker 2001; Preiser and Vischer 2005). Another interpretation is that user needs are internal and personal states or conditions, rather than external elements, related to physiological, social or psychological well-being, and avoidance of harm. They act as goals that motivate the choice of environmental elements and attributes. Examples are health, physical and social safety, privacy, social contact, aesthetic experiences, autonomy, being part of society or feeling a continuity with the past (Kahana 1982; Sanoff 2000; Heywood 2004; Preiser and Vischer 2005; Keinonen 2008). These two views correspond with the meanings in most dictionaries. A third type consists of external elements combined with personal states or functional goals, e.g. a place to reflect on the past, a central area for information exchange or open spaces for play (Sanoff 2000; Hattis and Becker 2001; Zeegers and Ang 2003; Gifford 2017). Frequently, different types of user needs are combined in the same set.

Although all versions are valid, the different interpretations of user needs as elements, states or combinations of both and the mixing of these types of needs can lead to confusion. There is a preference for the second view. User needs in terms of elements or attributes pose a number of problems, while user needs interpreted as states have certain advantages.[1]

Needs that are formulated in environmental terms can limit the options in the design process to find optimal solutions. In user needs analyses aimed at cataloguing their wants concerning an object, users will be inclined to suggest familiar elements and attributes. However, familiar suggestions may not lead to better solutions and can distract from more appropriate or innovative ones. Environmental elements mentioned as needs may in fact obscure underlying needs, which are less aware to the user. For example, one could indicate the need for an attic. Actually, there may be a need to store things for orderliness. An attic is a familiar solution. Other or better solutions for a need to store things do not come to light because the focus is on a need for an attic. Hence, a familiar element can lead a designer to try to find a solution in a specific direction that may be a so-called local maximum (in analogy with hill climbing: this is the top of the current hill instead of the top of another, higher hill).[2] A better solution or a 'radical' innovation (the highest available hill) could perhaps be found by another route that is unknown because the familiar element is taken as the point of departure (Norman and Verganti 2014). In other words: the designer may be creating an ideal attic instead of an innovative solution for storage space because to the users an attic is a familiar (and thus wanted) part of the house.

A list of needs should be neither too short nor too long. A difficulty with the quantity of needs in the form of elements and attributes is that the list is potentially endless, depending on the level of detail (e.g. the layout or the number of rooms versus paint color and the type of doorknobs). This can work in two ways. The vast amount of elements or attributes may be a cause for overlooking relevant needs or it may lead to naming too many less important needs. There is no guiding principle or

[1] Parts of Sects. 3.2 and 3.3 are adapted from a book chapter (see Heijs 2007a).

[2] The terms 'hill climbing' and 'local maximum' come from mathematical optimization techniques.

frame of reference to judge the comprehensiveness of the list, the relevance of such needs or the required level of detail.

In addition to the needs that users do communicate, the needs that are not mentioned require attention. A condition for avoiding undesirable design decisions and failure costs is that the program of demands, and the set of user needs that is the basis for it, are as complete as possible. For various reasons (other than the endless character of the list mentioned above), it is difficult to realize a comprehensive set of user needs if they are regarded as elements and attributes. First, users are often only partly aware of their wants because of a focus on present circumstances and inexperience with the new situation. For example, many elderly prefer a smaller house as it is easier to clean. It is quite possible that there is not enough storage room in the new house for important possessions but that this is not sufficiently understood.[3] Second, partial awareness may be due to the fact that some elements or attributes are self-evident or part of an automated process, so they belong to the so-called tacit knowledge of a situation. Such needs are not experienced consciously and they are easily overlooked. Third, users sometimes think prematurely that they are aware of all needs, so that the needs analysis is not thorough enough.

It is assumed that users are able to convey their needs to the person doing the interview or to the designer. Occasionally, however, it is difficult for users to think of certain needs (Kujala 2003). Users do not have the same information as a designer and sometimes the two parties do not appear to share the same language (the user-needs gap in Chap. 1). Users may seem incapable of explaining their wishes to designers who use another vocabulary (Massanari 2010). Under these conditions, the wishes can be less realistic with a view to the budget or the situation, which in turn may raise false hope and lead to a loss of trust if the wishes cannot be fulfilled. The role of the users can be passive or too modest as well. This can cause designers to impose their own ideas and take decisions that should have been avoided by involving the users in the design process (as in the first two cases in Chap. 1).

From a theoretical point of view, wants (needs as elements) are usually regarded as specific, superficial, transient and variable while needs seen as internal, personal states are considered as more general, fundamental, lasting and stable (Sommer 1983; Max-Neef et al. 1991; Heywood 2004; Keinonen 2008). These fundamental and lasting qualities make them more suitable for user needs analyses and programs of demands. Elements may become obsolete because of technological or societal developments but needs seen as states remain (e.g. a need for a land-line phone is outdated while a need for social contact is still there).

Needs that are regarded as states have a potential theoretical embedding that is lacking for needs in terms of wants. They can be related to theories on fundamental human needs and motivation like the hierarchy of needs of Maslow (the pyramid with physiological needs at the bottom, followed by safety, belonging, esteem, and

[3] Heywood (2004) reports that the 'HOOP' (Housing Options for Older People) methodology has been devised specifically to ensure that older people, in seeking a home that is perhaps easier to manage, do not overlook other housing qualities that may be equally important to them.

self-actualization at the top).[4] That type of needs has often been ignored by designers, while they can offer insight in possibilities to improve the interaction process between buildings and their users through design (Papanek 2019).

3.2.2 A Different Perspective

Given these complications and theoretical considerations it is advisable to identify two separate independent dimensions as in the P-E fit congruence model. The person dimension contains the user needs in terms of personal states, while the environment dimension holds the elements and attributes (or resources) to fulfill the user needs (see Sect. 2.1.4). In view of the validity and the reliability of user needs analyses and to avoid confusion, a precise definition is required. User needs must be defined as characteristics of the users without references to the environment. The definition should clarify how user needs are to be formulated, and mention the aspects that should be taken into account in a search for needs. The definition is as follows.

> **user needs** are physiological, social or psychological states of the users of an object (e.g. of a building), or activities to reach those states, linked to the process of use of the object, that contribute to the physiological, social or psychological well-being of the users in the process of use.

According to the definition, the nature of user needs can be physiological, social and psychological (e.g. *feeling rested*, *social contact* or *being safe*). Their fulfillment contributes to well-being in those fields. User needs are associated with the process of use of an object and they are derived from that process (this is explained in Chap. 4). There can be different user groups, each with a specific process of use and thus a specific set of user needs. User needs can be formulated as personal states. They can also be worded as activities to reach a certain state. In order to be functional in a design process, user needs should have a clear meaning for designers and users. States can be rather abstract concepts. It is often more informative to use concrete activities as a substitute (for example, *playing the piano* as a hobby instead of *self-actualization*). These activities reflect the user side of the interaction process (or the process of use; see also Sect. 3.3.2). In addition, Heywood (2004) states that needs of this type can be diverse, so they must be defined more broadly than fundamental human needs. Using activities can be a remedy because it allows for a greater variety

[4] There are versions with more levels, and the pyramid is only part of Maslow's theory of motivation (see Maslow 1970). Other such theories are Max-Neef's model of fundamental human needs (Max-Neef et al. 1991) and McClelland's needs theory (McClelland 2009).

of needs. Replacing or supplementing personal states with explicit activities is one of the steps in the method (see Sect. 4.1.3).[5]

User needs have a certain aggregation level, which can help to refine the search for elements and attributes that are required to fulfill the needs.

> **the aggregation level of a user need** is the level of detail of the part of the process of use the user need refers to.

Needs with higher aggregation levels relate to global or inclusive parts of the process of use and those with lower aggregation levels to small, more detailed parts. For example, *cleaning* can be a need with a higher level of aggregation, whereas *scrubbing the floor, dusting* and *storing equipment* have lower aggregation levels. User needs with a lower aggregation level are advisable when it is crucial to know all the steps in a process of use in case a design should be more detailed. This can be important for complex processes (see case 3 in Chap. 1) or target groups that have problems with certain tasks (e.g. cooking in case of particular motor disabilities).

The concept of user needs, interpreted as states and activities, is a crucial component of USE that differentiates this approach from others. In most approaches, a user needs analysis serves to identify user needs in terms of wanted elements or attributes, based on the object (sometimes with a state or a goal; see Fig. 3.2). During the programming phase, the user needs are converted into demands by including measurable criteria or technical specifications (see Sects. 2.2.2 and 3.3). Thus, needs and demands both refer to the environment and the difference between them is gradual rather than sharp. In USE, a user needs analysis establishes needs in terms of internal states and activities based on the process of use (with a fixed protocol, see Sect. 4.1.3). These user needs are fundamentally different from those in most other approaches. They do not represent the environment but the person dimension (consistent with P-E fit), and they are independent of desired elements or attributes. The needs precede the elements and attributes and constitute, as it were, an extra layer below them. This layer is not there if needs are regarded as elements and attributes. Only in the programming phase the matching elements and attributes for each need are sought and specified in the demands (see Sect. 4.2.1). Due to their independence, needs can serve as a neutral guide in the search for elements and attributes (the search directions in Fig. 3.2). In addition to their role as a guide in the search procedure, user needs have two other functions. They are added to the demands as motives for

[5] In practice, it may sometimes be opportune to introduce an additional fourth category of 'functional needs' which refer to everyday functioning such as household activities or work-related tasks (e.g. cleaning, storing, shopping). This category consists only of activities and has no states. Actually, all these activities can be linked to one or more states in the other three categories, but those links may occasionally seem too general or contrived (such as hygiene or health), whereas functional needs may be equally effective and more convenient.

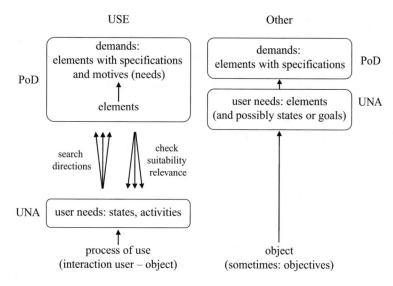

Fig. 3.2 User needs and demands in USE and in other approaches

the chosen elements and attributes (see Sect. 3.3) and they are used as criteria in a post occupancy evaluation (see Sect. 3.4).[6]

This interpretation of user needs helps to avoid the complications that can arise if needs are regarded as elements or attributes. With user needs as a starting point, the search procedure can prevent premature solutions and lower the risk of being trapped in a specific direction in the program (by familiar elements) or the design (in local maxima). Instead, it offers more flexibility by expanding the range of possible solutions and innovations. A structured search with user needs as a guide can raise the awareness of elements or attributes that may otherwise be overlooked due to their large quantity or because they are self-evident or a part of tacit knowledge. As a result, the program can be more *complete*.

In the opposite direction, the extra layer of user needs provides a frame of reference for assessing the relevance, suitability and adequacy of the level of detail of the elements and attributes that are found. This enables more *thoughtful* programs and designs without unrealistic or needless demands.

To achieve this, the extra layer of needs must also be comprehensive and cover the process of use. Assembling a set of needs that is as complete as possible is one of the goals of the method (see Sect. 4.1.3). As already noted, user needs in terms of states are stable over time. Such a set of user needs is usually also much smaller than a set of needs in the form of elements or attributes in relation to the same object (see Sect. 4.2.1), so that the amount is surveyable and a finite list of needs is

[6] There are other models that assume an additional layer next to preferred elements or attributes (e.g. means-end theory), but these layers, insofar as they are known, have a different composition, not reflecting (the user side of) the process of use, and different functions (see Sect. 4.1.3, Footnote 2).

feasible (Keinonen 2008). Because of the durable and finite nature of the needs and the systematic nature of a search for matching elements, the resulting program can not only be more complete but also *manageable*.[7]

This line of reasoning may seem complicated. An example can illustrate the preference for user needs as states or activities, the advantages of this type of need as a guide for searching matching elements and as a motive in demands, and the importance of a complete set of needs to start with.

People can say they need a spare bedroom. A spare bedroom is of course not a genuine human need. This need can be found by asking why a spare bedroom is wanted. The answer may be that there is a need for *privacy* or, more in particular, a need *for not being observed* or *to seclude oneself*. If the spare bedroom is the need, without reference to privacy, the program of demands will contain this bedroom with certain specifications such as size, form, location, layout and perhaps furniture. However, if *privacy* is the need, a search for the relevant elements will produce more results in addition to a spare bedroom (e.g. a high fence, opaque window coverings or a second toilet). This collection may even be larger and more accurate if concrete substitute needs (i.e. activities) are used. The need for privacy can also provide inspiration for innovative elements (e.g. novel ways to cancel out noise). The results can be referred back to the needs to check their suitability and feasibility. Adding a need *for not being observed* or *to seclude oneself* as a motive to the element spare bedroom in a demand (see Sect. 3.3.2) may lead to more appropriate, and possibly different, design decisions (e.g. the application of blinds or a certain room size).

The fact that a set of needs should be complete can be illustrated with the example of elderly who want a smaller house because it is easier to clean (see Sect. 3.2.1). Only if the set of needs covers the process of use, so a need *to store valued possessions* is on the list together with a need *to clean the house*, a proper choice can be made. An inclusive overview of user needs can help to detect such conflicting demands on time (see Sect. 3.3.2).

3.3 The Nature of Demands

A program of demands, also referred to as a design brief or a program of require-ments, is used in the fields of, among others, architecture, facility management and product development to guide the process of design and production or construction. It is the information base for a project and for communication between the various parties involved, it supplies criteria for the design review and the post occupancy eval-uation (see Sect. 3.4), and it has a number of formal functions, such as substantiating contracts and guarantees, and monitoring the financial and time budgets.

[7] The fact that USE produces a more complete program was verified in research on apartments for the elderly (see Sect. 5.1). USE resulted for example for the kitchen in 59 substantially different demands instead of 16 in a traditional program (i.e. Woonkeur) and for the hall in 35 demands instead of 11.

There are different recommendations regarding the content of a program of demands. The following is a combination of the formats proposed by British and Dutch building research institutions (BRE Trust, NEN, SBR; van der Voordt and van Wegen 2005; Designing Buildings Ltd. 2019). The first part of the program contains a description of the client. It offers information on the background (the organization, culture and objectives), the relation to the project (e.g. policies and expectations regarding health, safety and sustainability, criteria for success) and the functional (or user) requirements. These are qualitative statements about the user needs that should be satisfied (elements, attributes, possibly related work processes; e.g. a room for meetings). The expected visual quality or image can be a separate entry. A second part involves performance requirements. These are quantitative statements, in measurable terms, about the characteristics of the building needed to satisfy the functional requirements (e.g. a room of 30 m^2 for meetings). Building characteristics can relate to spaces, room types, zoning, thermal or acoustic conditions, safety, flexibility, etcetera. They are preferably not concrete solutions, so there is sufficient freedom of choice for the designer. The third part is about technical requirements, such as details on the structure, energy, comfort, sustainability, ICT and lifespan. The fourth part contains other conditions for the project, both internal (e.g. budget, time and organizational policies) and external (e.g. access, spatial planning, location, regulations and laws). The final part is for the remaining project data (identification of the project and the parties involved, duties, responsibilities, experts to be consulted, schedules and targets for evaluation).

A program of demands can be very complex and extensive and not all the information is available right away. A consultation of experts can yield new insights, other possibilities arise for solving problems, and technical limitations, unforeseen results and complications may lead to a change of plans. Therefore, a program cannot be drawn up in its entirety at the start of a project but it should gradually evolve parallel to it. There are at least three stages. A *statement of need* is drafted by designers and end-users or the paying client, which is a first impression of the possible requirements. Then the *strategic brief* is worked out with detailed requirements. Finally, the *project brief* is produced with the assistance of consultants that has all information for the design (Designing Buildings Ltd. 2019). Sometimes more stages are distinguished (a global, basis, structural, preliminary and total program matching the feasibility study, project definition, structural, preliminary and definitive design). A design team normally does not only rely on its own experience and expertise but also on external sources such as programs of demands and evaluations of similar projects, visits to such projects and data from interviews or workshops.

3.3.1 Complications

Sometimes there is no program of demands and existing programs do not always meet the recommendations. Quite often, they are sketchy with just some basic indications of required spaces and surface areas. Prescriptive programs that consist of solutions

are not uncommon and so are programs written in one go at the start of the project or assembled by a designer and paying client without contributions of the end-user (see Chap. 1). The demands are often user needs, worded as elements or attributes, extended with criteria (see Sect. 3.2.2). Thus, complications affecting this type of need may also apply to these demands (such as familiar solutions and elements that are overlooked for various reasons, see Sect. 3.2.1). Usually, demands do not include states or activities that can be regarded as motives.

Nearly all the examples of demands or programs in the literature concern the primary or core process in a building and the users and locations that are related to this process. Other user groups, processes and locations are not often mentioned (groups such as visitors, customers or persons with a disability; activities like walking, eating or casual social processes; places like a canteen, storage rooms or circulation areas). If there are more user groups, it is likely that there are also different processes of use and sets of user needs. In that case, the program may not be complete.

Measurable criteria can be useful for design and evaluation. They should be carefully worded as directions for solutions instead of actual solutions, so they do not unnecessarily restrict the freedom of choice in the design process. It is not always possible to use measurable terms because certain characteristics are intangible (e.g. aesthetic quality) or subjective (e.g. the perceived temperature).

3.3.2 A Different Perspective

Unlike most examples in the literature, a program of demands in USE has to contain, as far as possible, information about all user groups, processes of use and locations. This is necessary to avoid adverse effects and failure costs because of the design. The focus is on a *functional* program that, in terms of the previously discussed formats, contains the functional and the performance requirements but in an adapted form. Other information (on the background of the client, the technical requirements, the internal and external conditions and the remaining project data) should be integrated later in a total project brief. It is assumed that, if a functional program as the central ingredient is satisfactory, a major barrier is crossed towards a suitable design.[8]

In a P-E fit approach the environment dimension represents the resources that match the user needs. Previously, this environment side has also been identified as elements, attributes or performances. Performance is a well-established concept for programs of demands, whereas the other terms do not entirely cover the intended meaning. Thus, performances are applied in USE as the counterpart of user needs in the interaction process (or the process of use) with the following definition.

[8] The functional program is aimed at the functionality of the design and its fit with the process of use. It is not intended for construction. This requires additional translation and technical specification.

a performance is a characteristic of the environment (e.g. of a building) that is necessary to satisfy a user need (in a certain location).

This definition is broader than in other approaches, where performances may be restricted to building attributes, because the method is usable for a wider range of objects and situations. Performances can be objective or subjective (see Sect. 3.3.1). A location (or part of an object) can be added as specification. Another distinguishing aspect is that performances in USE are *necessary* for the fulfillment of a need. This differentiates them from features that may be experienced as disproportionate or luxury. It makes a program more efficient as well. Two types of performances need some explanation: preferences and transactional qualities. The term preferences is often used to specify relevant environmental characteristics. They can be seen as comparative performances (preferred among alternatives given their relative utility for satisfying needs). So-called transactional qualities are special attributes that can typify a person and an environment (such as safety, privacy or comfort). They give the impression that these attributes are shared in a transactional relation (e.g. the environment is comfortable and so is a person in the environment because of their mutual interaction). Transactional qualities can be used to specify both performances and user needs. Sources for finding performances are described in Sect. 4.2.1.

Demands in USE are called *functional demands* because the focus is on a functional program. The name also serves to make a distinction between this format and formats in other approaches. The definition is as follows.

a functional demand is a combination of a user need (motive) and a performance.

As stated earlier, the addition of user needs as motives to demands allows more deliberate design decisions because motives facilitate an appropriate interpretation of the demands. The designer will be better informed about the intended outcome if the intention itself is also clarified (e.g. a fence *to keep a dog inside* may be different from a fence for *visual privacy*). Using needs as motives conforms to human need theories and to P-E fit models. The personal dimension and the environmental dimension converge in the functional demands. Each functional demand expresses a certain aspect of the interaction between the users and the environment, through the needs in terms of states or activities and the related performances. In the search for suitable performances, a user need is usually associated with several characteristics and each combination is a functional demand.

During the search, the user needs are also used to reflect on the relevance, suitability and level of detail of the performances (see Sect. 3.2.2). This level of detail is expressed in the aggregation level and the solution space.

the aggregation level of a performance is the level of detail of the part of the environment (e.g. of a building) the performance refers to.

Performances with higher aggregation levels refer to larger, less detailed parts of the environment (e.g. the entire building) while those with lower aggregation levels concern more detailed parts (e.g. rooms or corridors). Performances of more specific parts may be important for certain groups or processes of use. For people with motor disabilities, for instance, there should perhaps be specific performances concerning the accessibility of rooms, corridors and elevators instead of the accessibility of the building as such. Thinking critically about the level of aggregation can prevent a program from being incomplete or too specific.

In addition, performances have a certain solution space. A solution space expresses the degrees of freedom for a designer to find concrete solutions.

the solution space of a performance is the range of possible solutions to achieve that performance.

Performances in broad or general terms have a larger solution space while specification of a performance can reduce its solution space. For example, *having enough light* is a performance with a larger solution space. This is reduced in the performance *having enough artificial light*, and even more in the performance *having fluorescent lighting of type X with Y lux*. In the last case, the performance has the smallest solution space possible (1) and the designer has no freedom of choice: that performance *is* the solution. Large and small solution spaces both have advantages and disadvantages. If a solution space is as small as 1, the result will be exactly as expected. There is maximum control, but the designer's creative freedom is limited and complications may arise such as mentioned in Sect. 3.2.1, in particular a familiar solution that is not the best one or a design that is stuck in a local maximum without a chance for innovation. On the other hand, in case of a large solution space, the user will not know precisely what the solution will be. There is less control, but the designer has more freedom and has the opportunity to find innovative solutions, to combine several demands into one solution or to solve conflicts between demands (this is explained below in relation to the programs of demands). If a specific performance is needed to satisfy a user need, or if there is only one particular solution, a small solution space is acceptable. If conditions are less strict, solution spaces can be larger and usually a larger solution space is preferable.

Solution spaces can include quantitative specifications but qualitative or subjective (less tangible) attributes can also be used. The combination of motives and solution spaces in functional demands is especially intended to facilitate a process of reflection on the fulfillment of user needs while retaining enough freedom of choice in the design

phase, and to be able to discuss this with the users in terms that are understandable to both sides.

Aggregation levels and solution spaces should not be confused. A rule of thumb may be that changing the aggregation level can change the number of demands (e.g. the accessibility of a building or the accessibility of the rooms, the corridors, etcetera), whereas changing the solution space will change the number of possible solutions but not the number of demands (e.g. a wide corridor versus a corridor of 4 m wide). These concepts are independent of each other: a higher or a lower aggregation level (the building or the corridors) can both be associated with a larger or smaller solution space (with enough light or with fluorescent lighting of type X).

Together the demands constitute the functional program of demands.

> **a functional program of demands (PoD)** is an ordered set of functional demands, serving to fit an object (e.g. a building) to the process(es) of use of that object.

Just as the demands can be seen as an expression of the different parts of the interaction, a functional program can be considered as a reflection of the interaction or the process of use as a whole. Needs and performances are consistently related to provide the designer with knowledge about the process of use so the design can be adjusted to it. If there are more groups of users, the program is a collection of the demands of all groups. Groups can be merged if the demands are the same (see Sect. 4.2.2). The ordering of the demands depends on the situation. Usually it is logical to sort them in sections for the entire object and for separate parts of the object, and then within those categories for all users and for subgroups. A program is not only an instrument for the design, but also for discussion and evaluation, so the structure and the terminology must be clear to all parties involved.

After ordering the demands, they can be prioritized to allow proper trade-offs during the design and construction phases. A priority is an indication of the importance of a demand for the designed object. This too requires a list of demands that is as complete as possible. The information contained in the program as a whole (motives, performances, levels of aggregation, solution spaces, locations and priorities) offers insight in the implications of trade-off decisions (e.g. what are the consequences if performances are not realized, which needs remain unsatisfied, etcetera; see Sect. 4.2.2). Such a program also facilitates the detection of potential conflicts between the demands and of opportunities to find solutions that fit several demands at once. Potential conflicts mainly concern demands that seem contradictory because the motives may lead to different decisions in the same situation (e.g. a *small house* for *cleaning* purposes or a *larger house* for *receiving guests*). Using opportunities for solutions that combine several demands can increase the efficiency of the design while reducing the costs (e.g. a room that is usable as a *bedroom* for *letting guests stay* as well as a *place* for *doing office work*). A proper assessment of conflicts and opportunities requires that the priorities are established for each demand separately

(for example, how important are a small house for cleaning and a large house for having guests rather than the importance of one over the other), since the priority of a demand can be relevant for more than one decision.

There is a bidirectional relation between the program and the design. The designer must find solutions for all the functional demands in the design process. This can require the merging of demands to arrive at a combined solution or the further partitioning of a demand leading to more solutions. Conversely, alternative solutions can be compared, refined and validated by checking back on the program and in particular by verifying whether the solutions fit the solution spaces and user needs. This will be repeated together with the users in the design review phase and the post occupancy evaluation (the translation of demands in evaluation criteria is described in Sects. 3.4.2 and 4.3.1).

3.4 The Nature of Evaluation

Post occupancy evaluation (POE) is intended to systematically investigate how a building functions when it has been completed and in use for some time (Preiser et al. 2016, 2018). POE is used to assess how well a building meets the expectations and how satisfied the users are (Federal Facilities Council 2001). In most cases, it contains a systematic comparison between realized and expected performances (the latter are the criteria for the evaluation) and an analysis of the gaps between these two. The goals are to identify and solve initial, unanticipated problems and, if repeated on a regular basis, to constantly fine-tune a building to the process of use. Besides feedback to the current project, POE has a feedforward function by gathering information for the improvement of future projects or designs in general. Other merits are a pro-active facility management (modification of buildings in anticipation of organizational change), better insight in the consequences of decisions, more satisfaction of the users through their active involvement and, as a result, a reduction of costs.

The remainder of this section mainly portrays the two versions of a post occupancy evaluation belonging to the approaches introduced in Sect. 2.2.2. The first is the elaborate and widely applicable version of POE in BPE, and the second is the structured evaluation method in performance based building, which is mostly aimed at office buildings. The emphasis is on a POE after completion. The evaluation in the design review phase differs: this is an assessment and a discussion in a smaller group of the plans, the motives of the designer and possible modifications (see Sect. 4.2.3).

Post occupancy evaluation in BPE can have various forms, depending on the situation (Preiser et al. 2016; Preiser and Schramm 2005). The choice of the form is based on the following considerations: (1) the extensiveness of the research; (2) the performances that should be evaluated; (3) the scale levels included; (4) the user groups involved and (5) the available and suitable instruments. An indicative POE is the least extensive. It is a short, exploratory study of the main positive aspects and problems using a walkthrough, archives and in-depth interviews with key persons.

A more extensive level is called investigative. It lasts up to half a year and uses fixed criteria, more instruments and descriptive statistics to assess the situation and tackle bigger problems. A diagnostic POE is the most extensive level and this is recommended in case of serious problems or if input for new projects is required. It may take a year or longer and it has a scientific character, using a multimethod approach and multivariate statistics. The choice of a level depends, among other things, on the type of problems and on the available resources (time, staff, budget). A POE can include technical, functional and behavioral performances (which are redefined needs; see Sect. 2.2.2). It can cover an entire building or it can be concentrated on smaller scale levels (e.g. rooms or facilities). Data can be gathered from the whole organization, groups or individuals. Finally, the instruments should match the objectives of the study and other choices. There are many possibilities, such as inspection of documents, site visits, walkthroughs, observations, surveys, interviews or exact measurements.

A POE project is subdivided into three phases: planning (an agreement on the feasibility and budget, and preparatory activities), the realization (data collection, analysis and coordination) and the application (reports, advice, discussion and a follow-up). The criteria, usually expected performances, should be objective and measurable. Specific values for these criteria can be derived from scientific literature, the evaluation of similar projects and resident experts (i.e. knowledgeable users). They can also be documented in the program of demands. Measures of the realized performances can be objective and exact (e.g. temperature measurements using a thermometer) or subjective (e.g. ratings of the perceived temperatures). Exact data may be collected unobtrusively without inconvenience for the organization.

Performance based building uses other criteria and data and the procedure for an evaluation is more structured. The Serviceability Tools & Methods (ST&M) approach offers tools for producing Statements of Requirements and building performance evaluation (see Sect. 2.2.2). The approach includes the methodology and scales from the ASTM, consisting of questionnaires to assess the workplace requirements of clients versus the capabilities of a facility to perform the functions for which it was designed (Szigeti et al. 2005). The two questionnaires are composed of matching, calibrated scales on a large range of topics (over 100). The method yields profiles of both sides and comparisons for the profiles and for each topic separately. It is standardized but it may be adapted to a specific situation: not all scales are needed and it is possible to create additional ones. The results can be used to develop a knowledge base for future projects and, aggregated across a portfolio or category of buildings, for benchmarking (Zeegers and Ang 2003; Szigeti and Davis 2005).

In addition, there is a variety of tools for building quality assessment and benchmarking (Zeegers and Ang 2003; van der Voordt and van Wegen 2005; Oseland 2018). Some instruments resemble the methods discussed above, while others focus on different sets of topics, standard criteria and requirements (key performance indicators). They can be intended for the evaluation of certain building types (e.g. the WODI toolkit, the Leesman Index and the former REN for work environments, primarily offices) or particular building qualities such as sustainability (e.g. LEED in the US and BREEAM in the UK) or health and safety (e.g. WELL).

3.4.1 Complications

In view of the advantages, one would think that conducting an evaluation of the functionality of a building is a matter of course. Still, it is often left out, presumably because of the costs and the time it takes. Other reasons may be that organizations are reluctant to expose possible problems or to invest in costly solutions, that the participation of users is lacking, or that it is difficult to mobilize internal or external expertise needed to carry out research with a certain scientific rigor (Federal Facilities Council 2001).

The most obvious source for evaluation criteria is a program of demands but sometimes a program is not available or not suitable (see Sect. 3.3.1). In these cases, possible alternatives are to use a standard set of criteria like ASTM or criteria from other sources (see above), or to assess situations without criteria, using satisfaction surveys, interviews, walkthroughs or observations. There is no prevailing method. Standard sets of criteria or performances, however, may not be entirely applicable to the objects in question, because they relate to specific building types or qualities. Some instruments are adaptable, but adaptation may interfere with an intention to generalize the results or use them for benchmarking, which requires a certain consistency of the instrument. Evaluation studies without criteria are often unique in nature (examples can be found in Preiser et al. 2018). The results can be valuable and useful in that particular situation but they may not be comparable to those of other studies, or be generalizable because of the variation in methods and subjects (Zimring et al. 2005).

If there is a program, the establishment of suitable evaluation criteria can still be problematic. For example, a program can be incomplete if it only focuses on the core process (see Sect. 3.3.1). In that case, additional criteria are needed for groups with other processes of use. A program can contain performances with higher levels of aggregation that refer to more parts or locations (e.g. *accessible rooms*). If those parts can be rated differently, a general question may give unreliable answers. Therefore, it is sometimes better to deviate from the program by choosing a lower aggregation level and to establish criteria for separate parts. Another example is an absence of user needs (motives) in the demands (see Sect. 3.3.1). If so, an evaluation can indicate whether the solutions match the expected performances but not to what extent the related user needs are fulfilled (e.g. while an office is rated positively for *accessibility*, it is not clear whether the associated, but unmeasured, need for *social interaction* is satisfied). Hence, criteria derived from needs in terms of states or activities should also be included. The examples show that criteria from a program must be well-considered.

There is some discussion about the use of objective versus subjective data and the added value of satisfaction ratings of realized performances. For example, objective data are recommended in performance based building. Meanwhile it is stated that subjective data (e.g. perception or satisfaction) are useful and that the two types of data complement each other (Szigeti et al. 2005; Szigeti and Davis 2005). In the instruments, however, there are few subjective variables. Research in the field of P-E

fit shows that subjective data (subjective fit) appear to be better predictors of overall well-being and behavior than objective indicators (see Sect. 2.1.4). While there seems to be a certain preference for objective data, there are variables that require subjective measurement (e.g. aesthetic quality and feelings of security). Thus, subjective data should be included. Ratings of satisfaction in evaluation research can be meaningless without a clear link to a possible cause of these ratings. However, they can have added value and offer useful information if the questions are sufficiently specified and if they contain practical clues to the potential causes.

3.4.2 A Different Perspective

Evaluation can be considered as the systematic assessment of a degree of fit. In methods for post occupancy evaluation (e.g. BPE and performance based building), this is generally the fit between the expected and realized performances. In P-E fit, it is the fit between user needs and the available environmental resources (which can be seen as realized performances). In the first case, the result expresses how well the designer has done the job of translating the program of demands (the expected performances) into a design or a designed object (the realized performances). A positive result does not necessarily mean that the users are satisfied with it. For example, needs may have been overlooked, so that the program, although carefully implemented, turns out to be suboptimal (see Sect. 3.2.1). In the second case, the result expresses the satisfaction of the users regarding the resources or realized performances (by definition, satisfaction is the feeling that needs are satisfied). Again, a good result does not imply a positive outcome of the other test of fit: the design can deviate from the program. Maybe there were trade-off decisions due to setbacks in the construction or budget, or new suggestions that were not in the program. Users can still be satisfied if the design allows their needs to be met. The two types of evaluation are complementary. Because of the setup of USE they can, in principle, both be carried out (see below). This can be useful: an analysis of the problems and of opportunities to optimize buildings from different angles can result in a more inclusive picture and more knowledge for future projects.

The first type is called a *formal evaluation* because the comparison of the expected and realized performances can serve formal purposes, such as a check of the design against the program and contract, and monitoring the budget. It can also be useful for facility management and benchmarking. The criteria are the expected performances in the functional demands, as reflected by the solution spaces. The aspects that are evaluated consist of the realized performances of the applied solutions. This is analogous to a regular post occupancy evaluation. The central idea is the following.

a formal evaluation is a systematic verification of the extent to which the realized performances (solutions) of an object (e.g. of a building) fit the expected performances (solution spaces) in each functional demand

Both the criteria and the realized performances in a formal evaluation are objectively measurable. They are verifiable quantitative and qualitative characteristics (e.g. sizes and materials). An example of a demand with an objective criterion is *a room of 50 m²*. The question can be: to what extent does *the size of the room* (realized performance) fit the condition of being *50 m²* (expected performance)?[9] This condition is verified with objective measures. Subjective *expected* performances (criteria like a *large* room or a *beautiful* building) are usually too unreliable and elusive to assess either objective or subjective actual situations.[10] In the context of an evaluation, subjective performances can only be used as *realized* performances (e.g. a *perceived actual temperature*). Subjective realized performances could be assessed in a formal evaluation (e.g. by means of an estimate of the extent to which a subjective temperature corresponds to a given objective value) but they are more aptly represented in the functional evaluation described below, which uses criteria that are subjective as well.

The second type is termed a *functional evaluation* because the fit between user needs and available resources reflects the functionality or usability of an object (or building). Based on P-E fit theory, it employs the user needs in the demands as criteria, instead of expected performances, to evaluate the realized performances. The results of a functional evaluation show to what extent the realized performances in a design conform to the needs of the users (the motives in the demands). In other words: it is an assessment of the quality of the parts of the interaction (or the process of use) that are reflected in each demand. The definition is as follows.

a functional evaluation is a systematic assessment of the satisfaction with the fit between the realized performances (solutions) of an object (e.g. a building) and the user needs (motives) in each functional demand

The criteria in a functional evaluation are subjective (user needs in terms of states or activities). User needs should be sufficiently clear to be usable as criteria. The realized performances can be objective or subjective. If a functional demand is *a room of 50 m²* (or *large room) for staff meetings*, the question can be: how satisfied are you with *the size of the room* (real or perceived realized performance) in view of *staff meetings* (user need)? The user needs offer insight in the possible causes of the

[9] For the format of evaluation questions and more examples see Sect. 4.3.1 and Chap. 5.

[10] For example, *how well does the (actual or perceived) size fit the criterion of being large* is a difficult question to answer or one that elicits different responses because the criterion (*large*) is vague.

(dis)satisfaction with the realized performances. The solution spaces of performances can facilitate the interpretation as well. Thus, bearing the user needs in mind, ratings of the satisfaction regarding the fit between realized performances and needs are relevant and meaningful in an evaluation. For example, the criterion *staff meetings* is an activity that is known to the users and offers a clear understanding of the meaning of the satisfaction score.[11]

Theoretically, formal evaluation is a test of objective fit (or congruence) and functional evaluation of subjective fit (or perceived fit; see Sect. 2.1.4). Functional evaluation is not a regular method for building evaluation. In most research, there is little attention for user needs in terms of activities or states (Bain 2018). As shown by P-E fit research, however, subjective fit is more important than objective fit for well-being and behavior. That the result of a functional evaluation may be more significant than that of a formal evaluation can be illustrated with the following example. If users are not satisfied with the temperatures in the office while the temperature readings fit the expected values, the opinion of the users should probably carry more weight because that affects their well-being and productivity. Thus, if the subjective fit is low, an objective fit may not provide enough compensation. Conversely, if the users are satisfied with the temperature when it does not exactly meet the expected values, this will probably not be seen as a problem (perhaps as a reason to adjust the expected values). Thus, if the subjective fit is high, objective fit also seems less important.

As mentioned above, the joint use of both types of evaluations has certain advantages. However, this is not always possible. For example, a program may be lacking. Sometimes the demands are too global or do not contain objective performances, which means that no criteria can be derived for a formal evaluation. If there are no usable criteria, a possible solution is to use a set of standard criteria. However, this not an option because in USE an evaluation is tailored to a particular object and the method is intended for very different objects and performances (for example, it was used to evaluate nursing homes, sporting facilities and a chemistry department). Thus, without usable criteria a formal evaluation is not viable. In contrast, a functional evaluation is almost always achievable, even if a program is missing or unsuitable (with expected performances that are subjective or vague) or if no user needs are mentioned. If it contains performances but no needs, these needs can be added later. If there is no program, USE has the option of creating a special program, only for evaluation purposes, in which needs are linked to locations instead of (the lacking) performances. The combinations of locations and needs can be used as an alternative to rate the functional qualities of a design. These possibilities are explained

[11] As explained in Sect. 2.1.4, there is a distinction in P-E fit between supplementary and complementary fit. In the functional evaluation in USE complementary fit is involved. Satisfaction with the fit is an operationalization of subjective fit. It is a direct measurement of fit (by asking the users instead of deriving it from effects). Usually, commensurate dimensions are recommended to measure P-E fit (matching qualities of the users and the environment as in supplementary fit). Non-commensurate dimensions are less common but not impossible, especially in cases of complementary fit (Kristof 1996; Ostroff 2007, 2012). Here the dimensions are non-commensurate since designed objects and user needs are clearly different (but related) domains and the focus is on complementary fit.

in Sect. 4.3.1 because this requires some knowledge of the protocol for user needs analysis in Sect. 4.1.3.

The results of the two evaluations reflect the fit between *separate* realized performances and associated expected performances or user needs. In the context of a functional evaluation, an aggregate measure has been created that combines the evaluation scores and indicates the *overall* degree of fit between realized performances and user needs related to an object. This is called the *functional value*. It is a quantitative measure for the usability of an object or for the quality of the interaction (or process of use) regarding that object. It is defined as follows.

> **A functional value** is a quantitative measure that expresses the perceived overall fit between the realized performances (solutions) and user needs, in relation to an object (e.g. a building) and a user group

A functional value is associated with a certain object and user group, and therefore it is specific for a certain process of use. The functional value of the same object can be different for other groups with different processes of use (e.g. for those engaged in core activities or for maintenance staff).

The functional value is a measure of subjective fit. It depends not only on the satisfaction regarding the fit between realized performances and user needs but also on the perceived importance of that fit. If the fit between a performance and a user need is perceived as more important than another fit, the fit in the first case should contribute more to the functional value. Therefore, the functional value of an object should be a weighted sum of the satisfaction scores for all performance-need combinations with ratings of the importance of the fit as weights.[12] However, if this weighted sum is used, an object with more important performance-need combinations can have higher (or lower) functional values than an object with unimportant combinations. In other words: the functional values of objects may not be comparable because the ranges of those values depend on the importance ratings. Thus, it seems more appropriate to regard the functional value as a percentage of the range of values of the weighted sum that are possible in a situation with certain importance ratings.[13] If 'min' and 'max' are the results of the weighted sums for the minimum and maximum satisfaction, the functional value is given by the equation: (weightedsum − min)/(max − min) * 100.

[12] Using the importance of the fit as weights is also advised in P-E fit (Cvitkovich and Wister 2001). Questions on importance of the fit and on satisfaction with the fit should have the same subject. For example, if a question on satisfaction refers to *the size of the room for staff meetings* the question on the importance should be: how important is *the size of the room for staff meetings*?

[13] As an example, an object with unimportant combinations (such as a barely used room) can still be very useful for the function it has (such as storing unimportant items). The maximum unadjusted functional value of this object, however, is low compared to that of an object with very important combinations. The low value gives the impression that the usability can be improved while this is not possible with the given importance ratings. In principle, the first object should be allowed to reach a similar usability level as the second. The corrected functional value has the same possible range (0–100%) for every object, regardless of the importance of the combinations involved.

This is termed interval standardization (e.g. in multicriteria analysis). For satisfaction with the fit, a bipolar scale is used ranging from −5 (very unsatisfied) to 5 (very satisfied) and importance of the fit is rated with a unipolar scale from 1 (not important at all) to 10 (very important). Using the minimum and maximum values of satisfaction in the equation mentioned above leads to the following formula for the functional value.

$$FV = \frac{10 \sum_i w_i S_i}{\sum_i w_i} + 50$$

In the formula FV stands for the functional value of a certain object. The i denotes the i-th combination of a realized performance and a user need belonging to the object. S_i is the satisfaction with the fit in combination i and w_i is the importance of the fit in combination i (the weight). The sum covers all the combinations. The coefficients follow from the scale values that are used. The formula is a proportion: the numerator is expressive of the uncorrected weighted sum and the denominator of the range, which is dependent on the importance ratings alone (because S, as a maximum or minimum, is a constant). Since it is a percentage, the functional value of an object ranges from 0 to 100.[14]

The two evaluation methods can be used to trace the underlying problems and the causes of low evaluation scores and to set priorities for corrective measures in the management plan. Insight into the nature of the problems and causes is obtained by posing open questions on these subjects in case of lower scores in either type of evaluation, by considering the content of the performances or needs involved and by using any available correlated data on an object. For example, evaluation scores indicating low thermal comfort or social security can be related to the spread of temperatures or security incidents and, in view of causality, to other environmental factors with a known impact.[15] In order to formulate measures, it is necessary to first identify the locations or performances that warrant higher priorities because of the gravity of the problems. Then, the sources mentioned can be used to prepare the appropriate interventions. This way, the measures can be specifically tailored to that situation, which can make them more effective. Section 4.3.2 contains additional details on the nature of the results of both evaluation methods and on the process of establishing priorities and measures.

As said above, standard criteria are incompatible with the specific nature of the evaluations in USE. Benchmarking can be a problem, because this also requires a standard set of variables while performances are diverse. However, user needs can be a viable alternative. These needs will show a larger variation in content in the functional demands (usually as concrete activities), but at a higher level of aggregation, they

[14] On the satisfaction scale 0 is not used because this score has no clear meaning (unsure or neutral) and neutralizes the influence of weight, and because the terms do not contribute to the outcome.

[15] This way, a focus on the fit between environmental variables and needs (or processes of use) may stimulate the application of the results of environment-behavior research in design.

form a smaller set of states to which the needs belong (such as physical health, social safety or thermal comfort; see Sects. 3.2.2, 4.1.3, Appendix A.3). This set is probably rather similar for objects of the same type (e.g. offices, nursing homes or houses). It is suggested to use needs with a higher aggregation level (the set of states) as indicator variables for benchmarking. The values of these indicator variables are the functional values that can be calculated for the performance-need combinations with the needs that are connected to the same higher-level needs (e.g. all the combinations with needs related to physical health, social security, thermal comfort, etcetera). These values can be used to establish criteria for new projects or for renovation plans, to compare buildings in a category with respect to indicator variables, or to monitor the developments in buildings or categories over time. As the amount of evaluation research increases, higher-level needs and related values for various object categories can be integrated in databases.[16]

3.5 A Parallel World

This book focuses on improvement of the interaction between users and buildings (or objects in general) through a better fit between user needs and building performances. There is also a parallel world with two other but related dimensions, which concerns the interaction between occupants (owners, tenants) and real estate, and analyses of the equilibrium between demand and supply. Both worlds deal with relations between people and the built environment and with sustaining the quality of the environment, bearing these relations in mind. Both worlds have concepts and methods to analyze needs, to transform the outcomes into new building plans and to evaluate the products. Because of these similarities, the question arises how USE is related to the other world.

In order to answer this question the differences need to be highlighted as well. These mainly concern the subject matter, the levels of analysis and the perspectives used. The world of user needs and building performances primarily deals with the micro level of separate buildings and their users, processes of use and functional value. Improvements are pursued through user needs analysis, programming, design and post occupancy evaluation. Related disciplines are in the social sciences (environmental psychology) and architecture. The parallel world of demand and supply centers on the macro level of building stock, owners or tenants, market mechanisms and economic value. In this case the principal means include market research, forecasting, project development, building and asset management. Market research consists of, for example, the large-scale satisfaction surveys and studies of housing preferences and plans to move, conducted on behalf of (local) governments and housing associations, and smaller scale methods like residential images, decision

[16] This suggestion has not been tested because USE is not yet used for repeated evaluation studies.

plan nets and stated choice experiments (Heijs 2007b).[17] Related disciplines are, among others, economics, real estate management and (urban) planning.

There is a situation in which the two worlds meet, namely when demand exceeds supply, as a result of societal or demographic developments, and new buildings, renovations or innovative concepts for living and working are needed. It is suggested that more attention should be paid to the needs of occupants since the market is no longer dominated by the supply side but is increasingly demand oriented. The design of new buildings or new concepts based on occupant needs requires a comprehensive program of demands. Market research, however, is not intended for this purpose and is usually less suitable. Environmental features that are assessed to chart needs in market research are too limited and not detailed enough to draw up such comprehensive programs and the interpretation of user needs in terms of environmental features may be problematic (see Sect. 3.2.1). For a deeper understanding of user needs and processes of use, and to arrive at new designs that truly fit contemporary needs, social design and related research methods are recommended as a complement to market research. USE is an appropriate method for separate buildings in the world of user needs and building performances and it can also be functional for larger projects and novel concepts in the parallel world if there are identifiable user groups and processes of use.

References

Bain B (2018) The college and university campus: facility assessments for long term decision making. In: Preiser W, Hardy A, Schramm U (eds) Building performance evaluation, 2nd edn. Springer International Publishing, pp 275–284

Cvitkovich Y, Wister A (2001) A comparison of four person–environment fit models applied to older adults. J Housing Elderly 14:1–25

Designing Buildings Ltd. (2019) Project brief for design and construction. https://www.designing buildings.co.uk/wiki/Project_brief_for_design_and_construction. Accessed 2 Nov 2019

Federal Facilities Council (2001) Learning from our Buildings. A state-of-the-practice Summary of Post-occupancy Evaluation. Federal Facilities Council Technical Report No. 145. National Academy Press, Washington D.C.

Gifford R (2017) Applying social psychology to the environment. In: Gruman J, Schneider F, Coutts L (eds) Applied social psychology: understanding and addressing social and practical problems, 3rd edn. Sage, Los Angeles, pp 351–381

[17] Satisfaction surveys are used to determine the policy concerning new developments and user related services based on the satisfaction with characteristics of buildings (housing) and environments. This is often supplemented by research on intentions and reasons for moving, and preferences regarding a selection of supply options. Satisfaction research looks back at existing features while preference research looks more ahead towards possible future characteristics. Residential images, decision plan nets and stated choice experiments are focused on choice processes and on related possibilities for design decisions, by analyzing choices and trade-offs concerning dwellings based on characteristics of images of dwellings in their environment or on housing attributes that are regarded as important.

Hattis D, Becker R (2001) Comparison of the systems approach and the nordic model and their melded application in the development of performance based building codes and standards. J Test Eval 29:413–422

Heijs W (2007a) User needs analysis and bridging the application gap. In: Edgerton E, Romice O, Spencer C (eds) Environmental psychology: putting research into practice. Cambridge Scholars Publishing, Newcastle, pp 30–43

Heijs W (2007b) *A model based reflection on demand analysis methods.* ENHR international conference 25–28 June, Urban sustainable areas. Rotterdam. https://docplayer.net/145083883-A-model-based-reflection-on-demand-analysis-methods.html. Accessed 22 Jan 2020. 17 pp

Heywood F (2004) Understanding needs: a starting point for quality. Housing Stud 19:709–726

Kahana E (1982) A congruence model of person-environment interaction. In: Lawton M, Windley P, Byerts T (eds) Aging and the environment: theoretical approaches. Springer, New York, pp 97–121

Keinonen, T. (2008). User-centered design and fundamental need. In: NordiCHI'08: Proceedings of the 5th Nordic conference on human-computer interaction 2008: Building Bridges, Lund, Sweden, pp 211–219

Kristof A (1996) Person-organization fit: an integrative review of its conceptualizations, measurement, and implications. Personnel Psychol 49:1–49

Kujala S (2003) User involvement: a review of the benefits and challenges. Behav Inf Technol 22:1–16

Maslow A (1970) Motivation and personality, 2nd edn. Harper and Row, New York

Massanari A (2010) Designing for imaginary friends: information architecture, personas and the politics of user-centered design. New Media Soc 12:401–416

Max-Neef M, Elizalde A, Hopenhayn M (1991) Development and human needs. In: Max-Neef M (ed) Human scale development. Conception, application and further reflections. The Apex Press, New York, pp 13–54

McClelland D (2009) Human motivation. Cambridge University Press, Cambridge

Norman D, Verganti R (2014) Incremental and radical innovation: design research vs. technology and meaning change. DesignIssues 30:78–96

Oseland N (2018) From POE to BPE: the next era. In: Preiser W, Hardy A, Schramm U (eds) Building performance evaluation, 2nd edn. Springer International Publishing, pp 21–27

Ostroff C (2007) General methodological and design issues. In: Ostroff C, Judge T (eds) Perspectives on organizational fit. Taylor and Francis Group, pp 352–356

Ostroff C (2012) Person-environment fit in organizational settings. In: Kozlowski S (ed) Oxford handbook of organizational psychology. Oxford University Press, Oxford, pp 373–408

Papanek V (2019) Design for the real world. Human ecology and social change, 3rd edn. Thames & Hudson, London

Preiser W, Schramm U (2005) A conceptual framework for building performance evaluation. In: Preiser W, Vischer J (eds) Assessing building performance: methods and case studies. Elsevier Butterworth-Heinemann, Oxford, pp 15–26

Preiser W, Vischer J (2005) The evolution of building performance evaluation: an introduction. In: Preiser W, Vischer J (eds) Assessing building performance: methods and case studies. Elsevier Butterworth-Heinemann, Oxford, pp 3–13

Preiser W, Rabinowitz H, White E (2016) Post occupancy evaluation. Routledge, London

Preiser W, Hardy A, Schramm U (2018) Building performance evaluation, 2nd edn. Springer International Publishing

Sanoff H (2000) Community participation methods in design and planning. Wiley, New York

Sommer R (1983) Social design: creating buildings with people in mind. Prentice-Hall, Englewood Cliffs, NJ

Szigeti F, Davis G (2005) Performance based building: conceptual framework. Final report. CIB (PeBBu) General Secretariat, Rotterdam

Szigeti F, Davis G, Hammond D (2005) Introducing the ASTM facilities evaluation methodology. In: Preiser W, Vischer J (eds) Assessing building performance: methods and case studies. Elsevier Butterworth-Heinemann, Oxford, pp 104–117

Voordt van der T, van Wegen H (2005) Architecture in use, Chap. 3. Programme of requirements. Elsevier, Oxford

Zeegers A, Ang K (2003) State of the art of performance based briefing. Final paper WP 2.2. Government Building Agency, Den Haag

Zimring C, Dogan F, Dunne D, Fuller C, Kampschroer K (2005) The facility performance evaluation working group. In: Preiser W, Vischer J (eds) Assessing building performance: methods and case studies. Elsevier Butterworth-Heinemann, Oxford, pp 180–187

Chapter 4
Method

Abstract While the previous chapter on the perspective and conceptual framework of USE was theoretical in nature, this chapter has a more methodological orientation. It contains step-by-step instructions for conducting user needs analyses, preparing programs of demands and performing post occupancy evaluations, with the underlying reasoning and a number of examples and suggestions to make the procedures more accessible.

Keywords User needs analysis · Program of demands · Formal evaluation · Functional evaluation · Functional value · Problems and measures

4.1 User Needs Analysis

A user needs analysis has three main parts. The first is the delineation of the object. In the second part the separate user groups are identified. Then the actual user needs analyses can be performed for each of these groups.

4.1.1 Object

Usually the object is a building, but user needs analyses can be applied to other objects as well. An object of research must be clearly defined, since this determines which parts of the environment and groups of users are to be included. It can be described as follows:

> **the object** of research consists of the object of design in a narrower sense and all parts of its physical context that can influence the design.

The object in a narrower sense is that on which the design is specifically focused. An object of research can be more extensive. If a design relates to a nursing home, for example, the object of the user needs analysis may cover an adjacent (semi-)

© The Author(s), under exclusive license to Springer Nature Switzerland AG 2022
W. Heijs, *User needs by Systematic Elaboration (USE)*,
https://doi.org/10.1007/978-3-031-02052-0_4

public space if it is important for accessibility. Possible future changes in zoning plans should also be considered. Then the needs of passers-by or (future) neighbors can be of interest. A larger object and more user groups will lead to studies that are more elaborate. A proper choice should be made, in consultation with the (paying) client and other stakeholders, bearing in mind that all processes of use related to a design must be included. One questionnaire can cover the entire object of research (see Sect. 4.1.3). However, sometimes it is recommended to use separate lists for different parts of an object (for example, the apartments, the building as a whole and the surroundings in case of a nursing home).

4.1.2 User Groups

A major goal of USE is to provide comprehensive programs of demands for design and evaluation that take account of all the relevant user needs. An overview of needs that is as complete as possible requires an analysis of the processes of use of all groups concerned (not only those involved in the primary process; see Sect. 3.3.1).[1] Another reason for analyzing all the groups is that this allows a better consideration of potentially conflicting demands in a design. Conflicting demands can be more common between groups than within groups due to different activities in the process of use (e.g. a non-slip floor in the bathroom for the safety of movement of hotel guests versus a smooth floor for cleaning by the staff). The third reason is that an accurate and correctly interpretable evaluation should be based on separate, homogeneous groups. Results might be biased or useless if they come from mixed groups with various processes of use.

User groups can be identified based on their processes of use. Although it is not an exact rule, the following indication can be used for the selection.

> **a separate user group** is a group of users with noticeable differences in the process of use compared to other users.

The motivation of this indication is that differences between processes of use can lead to other design decisions. At this stage, it is uncertain which differences are relevant. To be on the safe side, it is better to distinguish too many groups than too few. Groups can be rejoined later if they appear to be exactly the same with respect to the functional demands (i.e. needs, performances, levels of aggregation, solution spaces and locations). In a university setting, examples of separate groups can be teachers, students, secretaries, cleaning personnel and security staff. Some groups

[1] USE is focused on functional programs of demands, based on the process of use. There may also be demands with a different origin than this process of use (e.g. economic concerns of the paying client, legislation or technical requirements). These are integrated later in the total project brief (see Sect. 3.3).

appear to be overlooked quite frequently, such as people with a visual, auditory or mobility impairment, visitors and deliverers. Differences that seem small may still be important, for example between students in their early years and in the graduation phase or between lecturers and researchers, because the processes of use are different and they may need other facilities.

In residential settings, user groups are rather obvious. In other settings, such as larger organizations, identification of all relevant user groups is not an easy task. A good start is an organogram, followed by interviews with the personnel manager. A further preliminary investigation may be required to gain insight into the global activity patterns in a building. In addition, the users are not always known: new projects may need a study of previous research on similar situations. Inclusion of more user groups can be costly and time consuming or it can be regarded as risky because of disparities in culture and interests. Yet, a good overview is essential. A proper balance must be found between the number of user groups with significant differences and the available means, to create a situation that is representative and workable.

4.1.3 User Needs

When asked about their needs in the context of a design, most people tend to answer in terms of environmental elements or attributes (e.g. a kitchen, an attic, two large bedrooms; see Sect. 3.2.1). People are accustomed to using lists with tangible items, such as wish lists for birthdays and Santa Claus or shopping lists. Questions about needs in relation to a design will rarely elicit answers in terms of states or activities fitting the definition in USE. Generally, people do not think about needs that way and are less aware of such needs. This also applies to those performing a user needs analysis. It may not be easy to systematically change the habitual view on needs and design to the alternative perspective presented here. One must get used to the change of focus, so a proper training is suggested as well as a regular check on the results to correct mistakes. An instrument aimed to assist in identifying needs of the intended type is explained below.

The motives users have for wanting environmental elements or attributes usually consist of states and activities that *do* match the definition of user needs (e.g. *storing things for long periods of time* calls for an attic, *having guests to stay* requires two bedrooms). The elements and attributes are the performances to satisfy these needs (see Sect. 3.3.2). It is assumed that states and activities (needs) are related to performances in a cognitive structure in the memory of users that reflects the process of use. The structure also contains the locations of activities and performances, and problems (with their locations) that may obstruct the fulfillment of the needs. Figure 4.1 provides a diagram of such a structure.

At the top are the personal states. They are each connected to one or more activities to accomplish the states. An example is social security with the associated activities of locking the front door and checking who is there before opening the door. Sometimes

Fig. 4.1 The cognitive structure of a process of use

one activity is related to more states. Doors may be locked for security reasons, but also for privacy. Activities take place at one or more locations (spaces, rooms), and in order to carry out the activities, certain performances are required there. Because there are usually multiple performances per activity, they are indicated as a set {P} in a location. This may include a lock and a bolt on the front door in connection with locking, as well as a camera on the facade and a window overlooking the entrance from the living room in connection with seeing who is at the door. Several activities can be related to the same location and performance (the window in the living room also serves to look at the garden). At the bottom are potential problems, linked to an activity and (a performance at) a location. For example, the lock on the front door is not burglary proof and blinds by the window obstruct the view of the garden.

The upper half of the figure represents the user needs: personal states and in particular activities because states are usually not specific enough to be a motive in the functional demands (see Sect. 3.3.2). The lower half contains information that is usable in the program of demands or a post occupancy evaluation (locations, performances, problems). To identify a set of needs that is as complete as possible, and to uncover relevant other information, the structure must be unraveled or elaborated (hence the method's name). Three types of elaboration are used: supplementation, concretization and performance linking. Each serves to gradually approach the completeness of the set of needs and the functional demands.

a. Supplementation

The strategy of supplementation is intended to assist the users in naming as many user needs (and additional information) as possible. Although it resides in memory, the cognitive structure is not readily accessible, so a gradual exploration is in order. Through the interview protocol, relevant answers are supplemented by more relevant answers using the links in the structure (e.g. the activity *studying* leads to the state of *having knowledge*, which in turn leads to other activities such as *attending courses* and *doing projects*). The structure has four access points: locations, initial activities,

states and problems. Performances (elements or attributes) are unfit to be access points in view of the associated problems in needs research (e.g. because they are too variable and less surveyable; see Sect. 3.2.1). Of course, they do offer information for a post occupancy evaluation (see Sect. 4.3).[2] In order to supplement the data even further, the users are asked to verify a selection of general physiological, social and psychological needs known in theory, and of needs that, according to previous research, apply to the process of use in question. This also serves to monitor needs that may be unnoticed, for example, because they are self-evident. The overview of general and known needs is updated and extended after each analysis.

b. Concretization

During the supplementation process, the user may bring up needs (states or activities) that are too unclear to be usable as motives in the functional demands. They must have explicit meanings for a designer. Some states are abstract (e.g. *self-actualization*) while others are complex and cover several needs so a choice should be made (e.g. *safety*, which may include *physical* and *social safety* and also *feelings of security*). The same applies to some activities (*reaching the building* can refer to *driving there by car*, *traveling by train* or *using a bike*). In the case of states, supplementation usually results in more concrete activities (e.g. *having a hobby* instead of *self-actualization*) but some unclear states, and mainly unclear activities, require additional questions to make them more specific. A related issue is the aggregation level of user needs (see Sect. 3.2.2). For each need, it must be decided if the level is correct or whether it should be further detailed (e.g. does *using the library* provide enough insight for a design or would more details be needed on sub-processes such as *borrowing, returning* or *reserving books*?). Concretization is intertwined with supplementation.

c. Performance linking

The first two elaboration types belong to the user needs analysis. Linking of performances occurs in the next phase, the program of demands, when each need is associated with one or (usually) more performances to arrive at a set of functional demands (see Sect. 4.2.1).

[2] There is some resemblance to means-end theory and the laddering method (Gutman, 1982; Reynolds and Gutman, 1988; Coolen and Hoekstra, 2001). This is mainly because in both these approaches a cognitive structure is studied that relates object attributes to internal states (values, needs). However, there are important differences in goals, structures and methods. Means-end theory and laddering try to find the meaning of products and the motives to choose them for marketing purposes. USE aims to uncover the process of use of buildings for the design. Means-end theory implies that products are preferred if certain attributes support the consumer's values. Through laddering ('why' questions), attributes are tied to a range of consequences (benefits, states, reactions of others), which are related to values. In USE, needs (states, activities) are traced first with various questions (the protocol) and then linked to necessary elements and attributes in a program of demands (see Sect 4.2). Starting points to unravel the process are activities, states, locations and problems, but, in contrast, not attributes (or elements), because they are at the end of the procedure and because they are too heterogeneous, variable and less surveyable.

Procedure

A user needs analysis consists of a series of structured individual face-to-face inter-
views with users of the groups involved, using a fixed protocol. The user needs are
determined separately for each group. Depending on the number of users, every-
body can participate or representative samples are drawn. If the samples are small
compared to the group (e.g. because users are hard to reach or resources are limited),
it may still be possible to obtain more information about the group by questioning
respondents as group members (by referring to 'group' instead of 'you' in the
protocol).

The protocol handles the supplementation. The interviewer must attend to the
concretization and the aggregation level of activities. The information must be clear
and unambiguous to be usable in a program of demands and a post occupancy evalua-
tion. The various topics should be well queried to allow the emergence of the different
types of user needs (physiological, social and psychological). These types are also
addressed by the overview of known needs mentioned under supplementation.

Answers are recorded into an Excel workbook consisting of three sheets, for
respondent details, regular supplementation, and general and known needs. The
columns are for entering information on locations, activities, states and problems.
The questions and instructions can be shown in split panes. The numbers of the
columns match those of the questions. Figure 4.2 shows part of sheet 2 (regular
supplementation). This is followed by a description of the protocol. Appendix A
contains the entire protocol, the sheets and the instructions.

The first three questions are explained using Fig. 4.3. Performances are omitted
since they are not access points. The circled numbers and arrows represent the ques-
tions. Letters in squares and thick lines indicate the new information that becomes
known. Words in italics and the 'object' in the questions must be replaced by real
names. The first access points are the locations, since those are easiest to recall (using
a map is recommended).

The questions are relatively straightforward. Each location produces one or more
activities and for each activity in a location, a state is established (by asking about the
purpose of activities in terms of states). In this case, there are 4 locations, 8 activities

User Needs Analysis Protocol

1a. Which locations (rooms, spaces) do you (does your group) use in 'object'? Please state name or number on map.
2a. Which activities do you (does your group) perform in *location*? (point out on map; complete column)
3a. Why do you *perform activity* in *location*? Why do you (does your group) do that? (if self-evident, no answer: general need)
Does *activity* in *location* have any other purposes? (repeat until no more states for that activity; then go to 4a)
4a. What else do you (does your group) do in 'object' for *state*? (all activities per state; after state go to 3a for next state)
5a. Where does *activity* for *state* take place? (complete for all additional activities in column 4; if new location, also add to column 1)
2b. What else do you (does your group) do in *location*? (complete for new locations; start in same row as new location column 1)

1. Locations	2. Activities	3. (Add.) States	4. Add. Activities	5. Add. Locations	6. Problems now	7. Problems future

Fig. 4.2 Sheet 2 (regular supplementation)

Fig. 4.3 Questions 1a, 2a, 3a (locations-activities-states).
1a. Which locations do you use in 'object'? Please state the name/number on the map.
2a. Which activities do you perform in *location*? (What do you do in *location*?).
3a. Why do you *perform activity* in *location*? Does this have any other purposes?

and 3 states. States are not only needed because they are user needs themselves.
They can also lead to other needs since states are usually linked to several activities.
Conversely, an activity can be connected to more states (as in the fourth and eighth
activity). The necessary performances for a need can depend on an associated state.
For example, there may be different requirements for locks for privacy or for security.
Thus, one should always ask about additional states (in question 3a). In the case
of multiple states, activities in the list of user needs and in the demands must be
mentioned together with the associated state.

When asking for states, assistance is sometimes needed because users are often
unaware of these states and the questions can therefore have a more or less unexpected
character (e.g. the state that is the purpose of having a meeting). If there is no
spontaneous answer after further questioning, the researcher can make a suggestion,
based on known states associated with the activity (in sheet 3), and check this with the
respondent (the purpose of meetings may be the state of *being informed*). Examples
make it easier for a respondent to subsequently associate other activities with states.
An explanation of the cognitive structure can also be helpful.

In this case, the user needs analysis is about an existing process of use. If the design
is intended for a new process of use, locations, activities, states and problems may
not yet exist so they cannot be access points. However, an entirely new process of use
is rare when it comes to buildings (for new software, it could be plausible). A process
can be new for a building (e.g. the adaptive reuse of a church as a bookstore) or a
group (e.g. a transition to flexible workplaces), but the process itself is almost never
completely new. In a flexible office, for example, various subprocesses already exist
(e.g. going to meetings or having lunch). User needs analyses are usually focused
on processes of use that are existing either in full or in parts, and that sometimes
include new activities or states. If (a part of) the process is new for a group or the

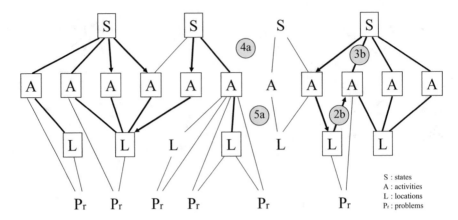

Fig. 4.4 Questions 4a, 5a, 2b, 3b (states-activities-locations-activities-states).
4a. What else do you do in 'object' for *state*?
5a. Where does *activity* for *state* take place?
2b. What else do you do in *location*?
3b. Why do you *perform activity* in *location*? Does this have any other purposes?

group is not available (if the users are not known), a user needs analysis must (partly) be performed in another, similar group elsewhere that is involved in that particular process (see the last example in Sect. 5.1). If a part of a process is really new, possible activities and states can be described together with the future users, the paying client and the designer. Expected daily routines are a usable starting point, followed by questions on states related to the routines and activities for these states.[3]

The next questions build on the states found earlier (see Fig. 4.4). The first question should find additional activities related to the previous states (now for the entire object). In the diagram, this reveals the fifth and eighth activity (and connections with the third and fourth known activity). Subsequently, the locations of these new activities are asked for, which may be the same as before or newer ones the user forgot to mention (the sixth location). There may be other activities in the new locations, so the next question is on that subject (the new link from the sixth location leads to a known activity). The last question aims to verify the completeness of the states, based on these activities. Usually, this does not add new states (as in this case). If other states are found, the questions must be repeated.

The third sequence has the remaining states as access points (Fig. 4.5). Now that respondents have become familiar with the concept of states, it is possible to use those as independent access points. Still, it is advised to mention previous states to make this type of information more prominent. New states may involve activities that were mentioned before and others that are remembered in relation to these states. In the diagram, the third state is used to further complete the set of activities. The last three questions are similar to those in the former sequence, leading to the fifth location and a new link with the eighth activity that is already known.

[3] In the exceptional situation that an entirely new concept of a building and pattern of use emerges, the design and the process will develop in an interrelated way. Special attention is then needed to ensure that both are in line with general human needs and known needs of that group (in sheet 3).

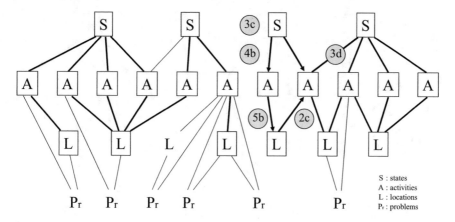

Fig. 4.5 Questions 3c, 4b, 5b, 2c, 3d (states-activities-locations-activities-states).
3c. Are there other states you pursue in 'object'? Which states?
4b. What do you do in 'object' for *state*?
5b. Where does *activity* for *state* take place?
2c. What else do you do in *location*?
3d. Why do you *perform activity* in *location*? Does this have any other purposes?

The final access point consists of problems people experience when they perform activities. These can be major problems but smaller ones can also provide relevant information. The focus is on building related difficulties. This limitation can already be made in the questions (due to 'object'), but because of this, certain problems can be overlooked, which at first are not linked to the building and later turn out to have a relationship with it after all. If this restriction is not to be applied, one may add to the explanation that other problems can also be important. These questions on problems serve several purposes: they can suggest more activities (user needs) and they can supply information that is helpful for composing the program of demands and for a post occupancy evaluation (see Sects. 4.2 and 4.3).

There are two question sequences. The first is about problems at known locations (Fig. 4.6; in this case without the limitation 'due to object'). The questions deal successively with possible problems with activities at locations in the present and the future (in order to be prepared for certain developments that may be relevant for the design and the evaluation), and desired activities that do not take place there because they are impossible. This is because the latter will not emerge from questions about activities that *are* carried out. The activities related to problems and the problems themselves are entered separately as user needs and as information for a post occupancy evaluation. In the problem description, the relation with the building should be clear. The diagram indicates a total of three current problems at the second and the fourth location (6a) as well as two future problems at the first and the sixth location (7a). All problems refer to activities that are known. Impossible activities (6b) are not shown; they are obviously not among the activities that are carried out.

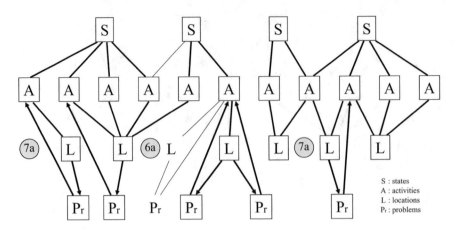

Fig. 4.6 Questions 6a, 7a, 6b (locations-problems-activities).
6a. Are there problems with activities in *location*? What are those problems?
7a. Do you expect other problems in *location* in the future? What are those problems?
6b. Are there activities that you want to perform in *location* that are not possible there? What are
those activities? (this is not shown in the diagram)

The other sequence (Fig. 4.7) is about the possible remaining problems that people
experience in the building in general (without a location as access point). The first
three questions have the same scope as the former sequence (the present and future
problems, impossible activities), except that the access points are the problems. The
sequence is rounded off with three questions on possible new locations, activities and
states found in previous answers. They correspond to the last three questions of the
penultimate sequence and they are a final check on the completeness of the activities
and states. Question 6c reveals one more problem (the third), while the questions 7b
and 6d are not offering more insight. This is a logical course of events because as the
interview goes on less information is unknown. Question 1b gives one new location
where no new activities or associated states are found (thus questions 7b, 6d, 4c and
3e are not in the diagram).

It will be clear that the process, by moving back and forth between access points,
and often having to supplement earlier information with new data without forgetting
something (e.g. new activities on previous locations or additional locations for activ-
ities), can become quite complex. This is the reason for using Excel sheets in this
protocol, where, if needed, rows can be inserted to put the information in the right
place (see Appendix A).

Sheet 3 is less complicated. This serves to check the relevance of general and
known (physiological, social, psychological) user needs of the target group and
possible additional problems. The first two columns show the states and the asso-
ciated activities, which are based on theory and former research in the target group
(see Appendix A.2.3). The access points consist of the states in column 1 that are not
yet listed on sheet 2. It is not necessary to question all the states or all the activities
in column 2. Some can be given as examples. If a state is found relevant, then those

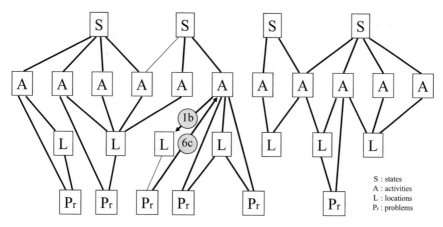

Fig. 4.7 Questions 6c, (7b, 6d), 1b, (4c, 3e) (problems-activities-locations-activities).
6c. Do you have any other problems in 'object'? What are those problems?
7b. Do you expect other problems with 'object' in the future? What are those?
6d. Are there activities that you want to perform in 'object' that are not possible there? What are those activities?
1b. Where does/will *activity/problem* happen? (for all new activities and problems)
4c. What else do you do in *location*? (for all new locations)
3e. Why do you *perform activity* in *location*? Other purposes? (for all new activities)

activities that according to the respondent are associated with this state are made bold in column 2 or added in new rows. Location(s) are added for each activity, and experienced and future problems for each activity in relation to a location. Finally, desired but currently impossible activities are attached per location and associated state. The description of the problems should clearly mention their relationship with the building.

At the end of the interview, information about the user needs is in column 3 (states) and 2 and 4 (activities) of sheet 2 and columns 1 and 2 of sheet 3. In general, activities replace most states (which are usually abstract). A state is seen as a need if there are no related activities. Mostly, it suffices to list separate activities and states. Adding a state to an activity is needed only if an activity belongs to more states and performances depend on the state (see question 3a). Locations are in columns 1 and 5 of sheet 2 and in column 3 of sheet 3. They only serve as access points to find needs. In the next step, they may be replaced by other locations (see Sect. 4.2.1).

After all the interviews are completed, a content analysis is performed to establish the final list of needs. Experience shows that applying this new perspective may not be flawless. To check whether needs are of the right type, the following questions can be asked during fieldwork and analysis:

(a) Is this a personal state or an activity of the *user* (or a combination)?
(b) Is this understandable and unambiguous for users and designer?
(c) Is the aggregation level correct, given the process and target group?

In the final list, user needs with a similar meaning but a slightly different wording should be merged and substantively different user needs should be distinguished without this leading to unnecessary fragmentation.

4.2 Program of Demands

A program of demands is set up by looking for appropriate performances based on the set of user needs. This is *performance linking*, the third type of elaboration, which results in a set of functional demands. The demands are then arranged in a program, prioritized and checked for conflicts and opportunities for combinations.

4.2.1 Functional Demands

Each need (activity or state) from the user needs analysis is linked to one or more performances with a certain level of aggregation, a solution space that indicates the margins for implementation and possibly a location (the needs are no longer tied to the locations in the protocol, so one is free to choose the same, another or no location in the performances; see Sects. 3.3.2 and 4.1.3). Figure 4.8 shows the links between the needs (ten activities A, one state S) and the new performances {P}.[4] Each link is a functional demand (FD). As illustrated by the figure, a set of user needs can lead to a significantly larger number of functional demands.

Suitable performances can be derived from various sources. A first option is an inventory among users with a questionnaire that connects to the user needs analysis. In a list, the personal needs from the analysis are arranged and elaborated. Users can indicate the performances considered necessary for each need and the importance of the resulting demands (for setting the priorities; see Sect. 4.2.2 and Appendix A). The second source are problems from the user needs analysis that may suggest

Fig. 4.8 User needs, performances and functional demands

[4] In the previous figures, the third state (S) was linked to an activity. This has been changed in the figure to illustrate the possibility that a state can be a user need if no related activities are found.

performances to prevent or solve them. The third method is to have a group discussion with users, in which performances are examined for each need. Fourth, one can benefit from the expertise and experience of designers or a design team, who can offer possibly original and innovative ideas. A fifth source is the research literature. This includes, in a broader sense, outcomes from environment-behavior studies and P-E fit research, and more in particular, for instance, thoughts based on the information processing model and concepts such as affordances, mapping or congruence (see Sects. 2.1 and 3.4.2). Sixth, similar projects may provide important knowledge in programs, design solutions and evaluation research. The seventh opportunity consists of instruments like checklists (e.g. ASTM; see Sect. 3.4) and patterns and design guidelines (Alexander, 1977; Cooper-Marcus and Sarkissian, 2000). A final source is common sense. To benefit from the various types of input, it is advised to start with a questionnaire among users and to combine this with other methods. The composition of a guiding team may depend on the sources, but should include users and the designer (see also Sect. 4.2.2).

At first sight, using a questionnaire for performances resembles the more conventional method, in which users are asked about wants and which is not without problems. However, there are vital differences in the starting point (the user needs or motives) and implementation (the search strategy and the description of the performances). The set of user needs provides guidance, so that a systematical and exhaustive search can be carried out. This decreases the possibility that relevant performances are overlooked. Besides, performances are not wants. In their description, more conscious and in-depth consideration is given to their necessity, solution spaces and aggregation levels, so that they do not turn into rigid or unrealistic wants, or distract from better or innovative solutions. Inevitably, users will refer to familiar matters in a questionnaire. However, the consequences of this are limited by a reasoned choice of solution spaces (e.g. an attic will only be mentioned if that is a conscious decision; see Sect. 3.2.1). (Dis)advantages of larger or smaller solution spaces are explained in advance, and solution spaces are verified with the designer, who can comment on performances that are unclear or unrealistic. This furthers the comprehensiveness of the program, the freedom of choice of the designer and, because the motives of the users are taken into account, the suitability of the design.

There are a few points to consider regarding the other options as well. If group discussions are used, it is important to watch over group dynamic processes such as a predominance of some participants and differences in terms of involvement, knowledge or experience (e.g. Hershberger, 2002; Taxén, 2004). Due to certain design preferences, designers can maintain limited solution spaces. Suggestions from the literature and performances in similar projects or checklists may seem to fit the present situation, but an apparent suitability can be deceptive. This must be carefully checked.

The aggregation levels and solution spaces of performances should fit the process of use and the target group (see Sect. 3.3.2). If the aggregation levels are too high, the performances may not contain enough information for a proper alignment of the design with the processes of use and for a reliable evaluation. If the levels are too low,

it could create an impractical amount of details and unnecessary demands. In solution spaces, a balance must be found between sufficient control over the results and freedom of choice in the design. A larger solution space, i.e. directions for solutions instead of actual solutions, is preferred. The specifications of the solution space can be quantitative or qualitative and objective or subjective. These properties are independent of each other; quantitative specifications can be objective or subjective (e.g. an exact or perceived temperature) and this also applies to qualitative specifications (e.g. a kind of material or its attractiveness).

The format of a functional demand, in line with the definition, is:

functional demand format: *performance* to (be able to)/for *user need.*

To illustrate this, a few examples are given for a university building (the aggregation level, solution space and location are subject to discussion).

enough tables (library)	to be able to	read
three lecture halls of 100 m^2	to	attend courses
rough floor finish (building)	for	physical safety
smooth floor finish (canteen)	for	cleaning
camera surveillance	for	a feeling of social security

Objects of research (see Sect. 4.1.1) are not mentioned in functional demands concerning that object. If there is an object in a functional demand, this is either a part of the object of research or an additional detail of such a part. In the above example of lecture halls, these are obviously parts of a larger structure that is the object of research, and the same applies to a room in *a room of 50 m^2 for staff meetings*.

Like user needs, performances and functional demands can be checked to see whether they suffice, among other things with regard to the needs (see Sect. 3.2.2). For performances, the questions are:

(a)　Is this a characteristic of the *object* (or building)?
(b)　Is this understandable and unambiguous for users and designer?
(c)　Is this necessary to fulfill the user need?
(d)　Does the aggregation level fit the need and target group?
(e)　Does the solution space fit the need and target group (preferably larger)?
(f)　Is the indication of a location appropriate?

For functional demands, these additional questions apply:

(a)　Are all user needs linked to one or more performances?
(b)　Are the links understandable and unambiguous for users and designer?

4.2.2 Functional Program

Once these questions have been answered and the content of the demands is accurate, they are combined in a functional program. If there are more groups, there will be different sets of demands. To assemble the program, the demands of the various groups should be screened for similarities and differences in the needs and performances, levels of aggregation, solution spaces and locations. If the demands of certain groups are identical on all those points, these groups can be aggregated. However, it is necessary to check whether demands that appear to be the same really are the same. In the case of needs or performances with a higher level of aggregation there may, after taking a closer look, still be differences at a lower level (e.g. a canteen for having lunch can be a demand that is shared by all the groups, but groups may think differently about the layout). Such demands must be rephrased to avoid misunderstandings. Then, they can be categorized. A logical arrangement consists of demands for the entire building and for separate locations. Within these clusters, a division can be made between a set that applies to all users and sets for specific groups. A program can take the form of a database. Next to the main fields with performances, needs and locations, this database can show additional fields with further specifications and categories of items to facilitate searching and making cross sections (see Sect. 5.1).

The functional demands contain performances that are necessary for the process of use. However, it is possible that not all of them can be realized due to the budget or other constraints. Therefore, it is necessary to assign priorities to the demands in order to be able to take trade-off decisions in the design and construction phase (to assess the effects, demands must be prioritized and not separate needs or performances). Prioritization can be supported by information in the program and, if available, by importance ratings from the performance inventory among the users (see Sect. 4.2.1 and Appendix A).

The structured program also provides an opportunity to identify potential conflicts between the demands, and possibilities to combine demands in a design in order to achieve more efficient solutions from a functional or a financial point of view (see Sect. 3.3.2). Conflicts and possibilities should be clearly marked so a designer can take them into account. A viable method is to make a pre-selection of relevant demands and compare these against each other in a matrix. Another check for possible conflicts can be carried out using the general and known needs on sheet 3 of the questionnaire in the protocol. Sometimes demands can be in conflict with one or more of these needs, even if they were not identified in the user needs analysis. If that is the case, it must be discussed. The list of known needs can also be used to monitor design decisions in the next phase. For the preparation of the program, it is recommended to expand the team of users and designer with several advisors, and to appoint a neutral chairperson (see Sect. 4.2.1). The advisors are the paying client and experts who can foresee financial and technical issues. This team can also be engaged in the design review.

4.2.3 Design Review and Design

The functional program of demands must be completed with the technical require-
ments, the internal and external conditions and other project data. It is developed
further in the next stages of the project up to and including the final design. Even
during construction, it can be modified (see Sect. 3.3). The present method provides
functional input for the overall program, the design review and the design, but it is
not intended to shape these phases. Nevertheless, a few comments can be made from
the perspective of USE.

Once the preliminary version of the design has been made, based on the program,
it can be submitted to the team in a design review. In this phase, the motives and
solutions proposed by the designer are checked against the functional demands, in
particular with regard to the intended process of use and the associated user needs as
a frame of reference (see Sect. 3.2.2, Fig. 3.2), and with regard to the solution spaces
of the performances. Because of earlier steps in the method, the risk of interpretation
errors in a design is significantly smaller, but they cannot be ruled out. In addition,
the chosen solutions may not be completely in line with the expectations. In a design
review, these issues can be explained and discussed. Besides, attention can be paid to
the way in which conflicts are resolved, demands are combined and possible trade-off
decisions are made. In the dialogue, alternatives can be considered and parts of the
design can be refined and improved. In addition to sketches and models, an important
tool is a so-called behaviorally annotated plan (i.e. a floor plan with annotations on
design decisions, motives and expected outcomes in terms of perception, behavior
and processes of use; see Fig. 4.9).

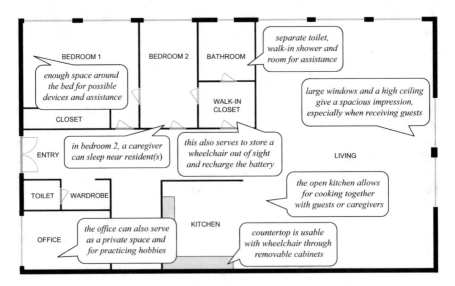

Fig. 4.9 Example of an annotated plan for a care apartment

Users play an active role in the phases in which their expertise is crucial, namely during the user needs analysis by specifying states and activities, in the programming phase by describing performances, and in the design review by discussing the design and possible alternatives. However, users are not designers. The design process itself is the domain of the designer, who is the expert (see also Kujala, 2003; Gifford, Steg and Reser, 2011). Although it may be argued that involving the users in the design enhances their satisfaction (see Sect. 2.2.1), the advantages of leaving this mission to a design team most likely outweigh the disadvantages. It is more efficient, since the users do not need to be trained in design skills or coached in the process. There is less chance of unrealistic decisions or design errors due to their inexperience, and designers are more likely to arrive at innovative solutions than users. Users do have control over the final results by being consulted during the design process when necessary, by their involvement in the design review, and by the fact that the decisions in the construction phase are made together. This control as well as the participation in other phases and the fulfillment of needs can ensure sufficient user satisfaction. A chairperson (possibly the researcher) can facilitate the communication during the design phase.

4.3 Evaluation

Evaluation research offers insight in the alignment of the design or object with the demands and process of use. The outcomes can be used to clarify problems and to formulate measures in the maintenance plan. The setting up of evaluation research requires a careful preparation. This includes the determination of the type of evaluation, the selection of the variables, the operationalization, the sampling and the fieldwork.

4.3.1 Preparation

For an evaluation the following preparatory steps are in order:
a. check and correction of the demands.
b. selection of the criteria, the performances and the type of evaluation.
c. identification of earlier problems as references for the assessment of improvements.
d. operationalization and preparation of the instrument.
e. sampling and organization of the data collection.

Evaluation questions are derived from functional demands, so a *check* is needed to ensure that the demands are complete and the performances are sufficiently clear. The fact that the program has been used for a design is not a guarantee for this. As stated before, programs may not represent all relevant user groups or aspects,

and some performances can be too broad or unclear to serve as a basis for reliable questions (e.g. because the level of aggregation is too high). The missing information should be added and ambiguities corrected to avoid inadequate answers. If this is not possible, those demands cannot be used in an evaluation. If this affects more than a few demands, a special program as described below may have to be used.

The next step is the establishment of the nature and origin of the *criteria* and of the *performances* to be evaluated, as well as the *type of evaluation* that can be performed. This depends on the data available in the program of demands. Implementation of both a formal and a functional evaluation is helpful because they scan a building from different angles, complement each other in terms of the information they give and, jointly, offer a better understanding of problems and causes. However, as stated in Sect. 3.4.2, this is not always possible. For the formal evaluation, the criteria are objective performances and for the functional evaluation, they are user needs. Such criteria can be unavailable if the demands have a different format or if a program is missing. The absence of objective criteria cannot be remedied, so a formal evaluation is not possible for the demands concerned. On the other hand, missing user needs and absent or inadequate programs do not necessarily result in the impossibility of a functional evaluation.

To allow a functional evaluation if performances are provided while user needs are missing, these needs can be recovered rather straightforwardly by asking why a performance is wanted or what it is intended for (i.e. the associated states and activities). This way the demands can be completed. It is important to continue asking until the answers are sufficiently clear to be usable as a motive, and to check whether there are more motives for a performance. If there are multiple motives, this results in more demands (one for each motive linked to that performance).

If a program is unavailable or if it is less suitable, a post-hoc user needs analysis can be performed to examine the process of use and to draw up a special program, only valid for a functional evaluation, in which the user needs are linked to locations instead of realized performances. Without a suitable program, realized performances are undefined. A location can be regarded as a container of realized performances, so that it can serve as a substitute for these performances. If the aggregation (or scale) level of a location is small enough, users can rate the satisfaction with the location, considering their needs (the criteria), in a meaningful way as an effect of the joint performances of that location. Subsequently, they can pinpoint the performances that cause a low satisfaction score (e.g. the satisfaction with room x for need y followed by open questions on the performances that lead to the lower rating). A special program is created with the user needs analysis protocol (see Sect. 4.1.3). The difference is that afterward the user needs are not linked to new performances (as in programming), but that the links with locations from the user needs analysis itself are used.[5] Thus, a

[5] A complete program of demands with expected performances (with a lower aggregation level than locations) is also a possibility, but this may require a disproportionate effort if it is for an evaluation and not for a new design. From a management point of view, the added value of a new program will usually not outweigh the results that can be achieved with a special program at lower costs. Besides, problems can still be related to specific performances using the information from the open questions.

Table 4.1 Possibilities for a formal and a functional evaluation

Content of demands (performance, need)	Formal evaluation (criteria × actual)	Functional evaluation (criteria × actual)
Objective + need	Obj. expected × obj. realized	Need × obj. realized
Objective only	Obj. expected × obj. realized	Added need × obj. realized
Subjective + need	–	Need × subj. realized
Subjective only	–	Added need × subj. realized
No demands/program	–	(Special prog.) need × location

special program can almost always be used as a replacement to perform a functional evaluation. If the program is partly suitable, those demands can sometimes also be subjected to a limited formal evaluation.

Table 4.1 offers an overview of the possibilities. The first column shows the types of demands. The next two columns mention, for the formal and the functional evaluation, the criteria that are used (the objective expected performances or the user needs; see Sect. 3.4.2) and the aspects of the actual situation that are assessed (objective or subjective realized performances, or locations in case of the special program). In summary, the table shows that demands with objectively measurable performances can be selected for a formal evaluation. Demands with needs and objective or subjective performances qualify for a functional evaluation. Demands in the format of USE already meet these requirements. User needs should be added to demands that only contain performances. If there is no suitable program, a special program is used. Examples are given below in the discussion on evaluation questions and in Chap. 5.

These two preparatory analyses must be carried out with a representative sample of users of all relevant groups. In case of a special program, the sample must also represent the relevant locations. Research for a special program has a mainly qualitative nature. It is important that all needs are mentioned; it is less important to know how often they occur. Therefore, the sample may still be limited in size if it is composed of users who have experience with the building and thus more knowledge of the process of use of the groups involved (a stratified sample of resident experts, formed during the fieldwork). The criterion for completing a series of interviews for a group can be that they do no longer reveal new needs. Interviewers involved in these analyses must receive a proper training (see Sect. 4.1.3). It is also advised to randomly check the interviews to rectify mistakes.

An evaluation can be an opportunity to assess the extent to which *known problems* have been resolved. Where these known problems are recorded depends on the type of evaluation and the phase in which it takes place. If it is at the end of a cycle that started with a user needs analysis according to the protocol (see Fig. 3.1 and Sect. 4.1.3), former problems (prior to the new design) have been identified in that analysis. The evaluation can be used to assess to what extent the new design was successful in preventing them. If the evaluation is part of a series on behalf of the regular building management, relevant problems would have been established in an

earlier assessment in the series. Then, the problems relate to the present building instead of the preceding one. Otherwise, it is not certain whether previous problems were documented. Possibly, there are alternative sources.

The following step consists of the *operationalization* of the variables and the *preparation* of the evaluation instrument. With the information on the criteria, performances and problems, the questionnaires can be compiled.

Questions in a formal evaluation concern the fit between the realized and the expected performances. They can take the following forms.

> **formal evaluation format**: (1) to what extent is *expected performance* realized; (2) to what extent/how well does *realized performance (attribute)* fit (the condition of being) *expected performance (value)*.

The first format uses the expected performance as a whole as a criterion. If the functional demand is *a room of 50 m² for staff meetings*, a question according to this format is: *to what extent is a room of 50 m² realized?* If the evaluation focuses on a specified value in the expected performance (e.g. a room *of 50 m²*), the second format can be used. In this format, the value is referred to in the realized performance by entering an applicable attribute (in this case: *size*). Thus, the question will be: *how well does the size of the room fit the condition of being 50* m²?

The functional evaluation consists of two questions, about the importance of the fit and the satisfaction with the fit between a realized performance (or a location in case of a special program) and a user need.

> **functional evaluation format, importance:** how important is *realized performance (attribute)* or *location* for *user need*.

> **functional evaluation format, satisfaction:** how satisfied are you with *realized performance (attribute)* or *location* for *user need*.

As stated in Sect. 3.4.2, the topics in the questions regarding importance and satisfaction must be worded the same. Applicable attributes are to be used in the realized performances to refer to expected values. For the demand above, the questions are: *how important is/how satisfied are you with the size of the room for staff meetings?* They should not address the expected performance (not: ... *a room of 50 m²?*) and they must refer to the content of the performance (thus: ... *the size of the room?* not: ... *the room?*).

Two other issues need attention while formulating the questions. First, the name of the object of research should not be referred to since the object is not part of the

demands (see Sect. 4.2.1). Second, demands may contain more aspects. Evaluation questions, however, should focus on a single aspect at a time. In the demand *three lecture halls of 100 m² for attending courses*, for example, there are numbers and sizes. These should be separate items. The same is true for locations with a higher aggregation level that can be rated differently (e.g. *accessible rooms*; see Sect. 3.4.1).

Keeping these general rules in mind, the questions can usually be derived rather easily from the demands, if they have been adjusted in the previous preparation steps. This is shown in the next examples, which correspond to the possibilities in Table 4.1. The demands are for an office unit.

1. objective (added need): a temperature of 20 °C (for doing office work).
2. subjective (added need): a moderately high temperature (for doing office work).
3. no (suitable) demand: (special program) 'location' for doing office work.

formal (1):	how well does the temperature fit the condition of being 20 °C?
functional (1, 2):	how important is the temperature for doing office work?
	how satisfied are you with the temperature for doing office work?
functional (3):	how important is 'location' for doing office work?
	how satisfied are you with 'location' for doing office work?

The first demand shows an objective performance and a user need. This permits both a formal and a functional evaluation. The formal evaluation answers the question whether the temperature complies with an objective criterion (20 °C) but not to what extent this temperature fits the process of use. That answer can be given in a functional evaluation. This establishes whether the temperature suits the criterion *doing office work* (user need). In that case, there is no relation with a certain temperature. Because both evaluations are possible, the situation can be examined from two sides to create a more complete picture. The second demand has a similar scope, but with a subjective performance. Therefore, a formal evaluation is not possible. The question *how well does the temperature fit the condition of being moderately high?* cannot be answered reliably because the criterion is too vague. The functional evaluation remains possible.[6] Although there is no link with an exact measure, the results of this functional evaluation are probably more important for building management when it comes to the well-being and behavior (i.e. productivity) of the users (see Sect. 3.4.2). In the last example, there is no (usable) program, so a special program is used. In that program, locations act as a substitute for performances, and certain locations are linked to this user need for the functional evaluation.

A somewhat special case concerns the company image, which often has a separate status in a program and can cause problems in an evaluation (see Sect. 3.4.1). From the perspective of USE, the company image is a user need and not a performance, similar

[6] As said in Sect. 3.4.2, performances in a functional evaluation are not used as criteria but only to specify realized performances. Thus, a functional evaluation is also feasible if performances are subjective without indications of exact values, such as *moderately high*. In case of demands such as *a smooth floor for cleaning* or *strict surveillance for social security*, legitimate questions can be asked about the satisfaction with *the smoothness of the floor for cleaning* or *the surveillance for social security*.

to self-actualization for individuals. Such abstract needs are better translated into more concrete states or activities to specify the intentions (e.g. a high-tech character, expressing hospitality or attracting clients). Then, the required performances can be formulated more explicitly and be combined with an exhaustive list of these concrete needs (e.g. the form of the facade to express hospitality, to attract clients, etcetera). These combinations can be assessed in a functional evaluation (*how important is the form of the facade to express hospitality* and *how satisfied are you with the form of the facade to express hospitality?*).

The questionnaires in both evaluation types consist largely of the central questions in the formats that are mentioned above, and of open questions on the nature and significance of the problems that cause lower ratings. In the explanation it is made clear that the search is about problems related to the building and the interior and that this relationship must be clarified in the answers. A convenient method is a questionnaire in a digital form, which allows the open questions to appear only if the scores on the main questions are low. This is called conditional branching or questioning. In addition, not everyone has to answer all the questions. For example, some locations may only be relevant for certain groups. Selection questions can be added to mark the locations a respondent uses on a regular basis or that are used less often while still being important for the process of use. This way, questions on non-applicable locations can be skipped. Likewise, the respondents can be given a choice to skip items that do not apply within a certain location. Thus, everybody can still receive the same questionnaire. Alternatively, different questionnaires can be sent to various groups via a link in the participation request.

In both evaluations, the answers to the open questions constitute the sets of current problems {Pr1}. If the problems in the previous situation or in a previous evaluation are known, that set {Pr0} is presented near the end of the questionnaire. For each problem, respondents are asked whether it has already been reported in {Pr1}, whether it has not yet been reported but is currently existing, or whether it does not exist (any longer). In the analysis, the sets are compared using these control questions (see Sect. 4.3.2).

As noted in Sect. 3.4.2, in a functional evaluation, the satisfaction with the fit between realized performances (or locations in case of a special program) and user needs is originally assessed on a bipolar scale (−5 to + 5) without a central point, and the importance of the fit on a unipolar scale (1 to 10). In practice, grades from 1 to 10 prove to be a useful operationalization for both these variables, because the meaning of grades is commonly known and intuitively clear. This also applies if the labels are only shown at the start and the end points (1. very dissatisfied—10. extremely satisfied; and 1. very unimportant—10. extremely important).[7] A 10-point scale is used in a formal evaluation too (1. fits very poorly—10. fits extremely well), so these questions are rated in a consistent way. This furthers reliability. The open questions

[7] In the Netherlands these grades have the following labels: 1 (very bad); 2 (bad); 3 (highly insufficient); 4 (insufficient); 5 (slightly insufficient); 6 (sufficient); 7 (more than sufficient); 8 (good); 9 (very good); 10 (excellent). It is generally known that a 5 or less represents the range of insufficient scores and a 6 or more the range of sufficient scores, so this resembles a bipolar scale without a neutral score.

are shown if the score is 5 or less in the formal evaluation or on the satisfaction scale in the functional evaluation. Errors can also be avoided by clustering questions per location. In the functional evaluation, all questions per location on importance of the fit are asked first, followed by all those on satisfaction with the fit and (in both evaluations) the open questions on problems. Doing this instead of alternating between subjects means that respondents do not have to constantly change their viewpoint.

Apart from the central questions, the open questions on problems and the selection questions on locations, the questionnaire contains characteristics of the respondents (group membership, structural variables to assess the representativeness of the sample, depth of experience with the building), date and time of completion, and an opportunity for comments at the end. The size of questionnaires can be reduced through conditional branching. If they still are too long, locations and performances may, cautiously, be grouped into broader categories (larger aggregation levels).

The operationalization of the formal evaluation needs one more addition. It may be possible to specify realized performances by means of concrete measurements, either by visual inspection (e.g. by counting) or by using instruments (e.g. a decibel meter or a thermometer). These specifications need to be included after each applicable question. Table 4.2 contains the general structure of the questionnaires.

The last step involves the *sampling* and the *organization* of the fieldwork. Because a formal evaluation concerns objective criteria and data, it is not necessary to use a large sample. It can be carried out by a relatively small group that, depending on the size of the project, is composed of a number of users (resident experts) representing the user groups and locations in a building, members of a possible facility management team and specialists who can help with the deployment of instruments and with identifying the exact nature and impact of the problems. This group preferably arrives at a joint opinion. A functional evaluation needs a larger and representative sample of users for reliable answers. If the plan is to draw conclusions for subgroups of users, these groups should be accurately represented as well.

The organization does not differ much from that in other field studies. As noted before, a digital questionnaire is advised, so conditional branching can be applied. An introductory letter or e-mail can explain the interest of the research (also for the users) with a request to participate. A link to the questionnaire can be included. If

Table 4.2 Content of the questionnaires for a formal and a functional evaluation

Explanation of the questionnaire
Characteristics of the respondents
Central questions (arranged in clusters per location, with selection questions) – Formal: fit realized—expected performances, possibly concrete measurements – Functional: importance, satisfaction fit realized performances (or locations)—needs
Open questions on underlying problems (conditional)
Control questions on previous problems (if applicable)
Other: date and time, comments

completing the questionnaire is more or less self-evident, instructions in the list can be brief. A realistic indication needs to be given of the time it takes to complete it. Usually, respondents appreciate feedback on the results and this can be used as an incentive.

4.3.2 Analysis

In the analysis of the formal evaluation, the realized performances and the locations can be selected that deserve attention because of a lower fit with the expected performances (see Table 4.3). This is shown by a score of 5 or less or a high frequency of such scores for locations. Then, the reasons for the low scores can be investigated. For this purpose, the problems in the open questions must be inspected, as well as problems that, according to the analysis of the control questions, still exist but were not mentioned in the open questions. This involves a description of both the nature and the significance of these problems, in relation to the ratings of the fit.

A formal evaluation uses a more or less predefined group of participants. In a functional evaluation, there is a sample of users. This sample must be described based on the data of the respondents and the locations involved. Subsequently, its representativeness for the applicable population of users (or user groups) of the building needs to be determined.

The first outcomes of a functional evaluation are the average satisfaction and importance scores for each fit between a realized performance (or a location in the case of a special program) and a user need across all users. These scores can also be obtained for groups of users of certain locations or with specific processes of use. A better understanding of the condition of a location is provided by the functional

Table 4.3 Subjects of the analysis for a formal and a functional evaluation

Formal evaluation
– Separate scores of the fit and possibly exact measurements
– Scores of the fit for locations
– Status of previous versus new problems, if applicable
– Underlying problems as possible causes of lower scores

Functional evaluation
– Description of the sample (users, locations), tests of representativeness
– Scores of satisfaction and importance for each fit
– Scores of satisfaction and importance for locations and user groups
– Functional values of locations, clusters and object for all users and subgroups
– Status of previous versus new problems, if applicable
– Underlying problems as possible causes of lower scores

Combination of formal and functional evaluation, or functional only
– Summary, interpretation of scores and problems
– Priorities and measures to be taken

Table 4.4 Example satisfaction (s) and importance (w) scores, and functional value

Performance-need		Resp1	Resp2	Resp3	Resp4	Resp5	Average
Wide front door to	s	7	7	6	6	6	**6,4**
enter with wheelchair	w	9	8	7	8	7	**7,8**
Spy hole front door to	s	3	4	6	3	4	**4,0**
look who's at the door	w	8	7	8	7	9	**7,8**
Large wardrobe	s	5	6	8	5	7	**6,2**
to receive guests	w	7	6	5	5	7	**6,0**
Recess with doormat	s	5	7	6	8	6	**6,4**
to wipe feet	w	7	7	8	7	9	**7,6**
Shoe storage	s	6	7	5	5	6	**5,8**
for hygiene	w	5	6	7	6	4	**5,6**
	FV	45,8	60,0	58,9	49,1	54,4	**53,6**
	Imp	7,2	6,8	7,0	6,6	7,2	**7,0**

value. This functional value is first calculated individually from the satisfaction and importance ratings regarding the fit between realized performances (or a location) and user needs, and then averaged across the users (see Table 4.4). If satisfaction is measured with grades, the scores must be recoded to the bipolar scale (5 to + 5) to use the formula in Sect. 3.4.2. Appendix A has a spreadsheet to compute the values mentioned in this section (with the recoding).

Table 4.4 shows an example, containing fictional data from an evaluation study of apartments in a residential complex for the elderly. It concerns a small selection of five performance-need combinations for the hallway in the rows and five respondents in the columns. For each combination the satisfaction (s) and importance scores (w) are shown with the averages on the right side. At the bottom are the functional values and the importance ratings of the five combinations for each respondent. These intermediate results are used to determine the overall functional value and importance of the combinations, which are needed for prioritization (bottom right).

Functional values can also be calculated for a spatial or functional cluster of locations or entire buildings. They can involve all users of a location or groups of users with the same process of use (e.g. all lecture halls used by bachelor students). Functional values of clusters or of entire buildings are established by using all combinations of performances (or locations) and user needs for that cluster or building. Using the average of the functional values of locations in a building to find the overall functional value of the building is not recommended. The values of separate locations are usually based on different sets of combinations, in terms of both content and size, so that dissimilar sets would be carrying the same weights in the average functional value. The analysis of current and past problems related to low satisfaction scores (≤ 5) is the same as in the formal evaluation.

The data from the evaluation research can be used to decide on corrective measures in the management plan. In order to do this, the locations with a greater urgency should be identified first. They can be distinguished in a functional evaluation by their lower functional value in combination with a higher average score of the importance of

the fit between the associated performances and needs. If the set of combinations is complete, the latter value is indicative of the importance of the process of use in that location. The lower a functional value and the higher the average importance score, the higher the priority of a location should be. The thresholds depend on the level of ambition. If this is high, a higher functional value and a lower average importance score can already trigger an intervention. The method has been used with functional values of 60 or lower and average scores of the importance of 7 or higher as cut-off points.

There are alternative methods to establish priorities. The first consists of determining the percentage of demands for a location that, in a functional evaluation, combine a low satisfaction (≤ 5) with a high importance (≥ 7). If that percentage goes above a certain preset level (for instance 40%), the location is assigned a priority. In this method, the setting of priorities is thus guided more by the number of 'misfits' than by average importance. Another option is to prioritize the performances instead of the locations. The average ratings of satisfaction and importance for each combination of a realized performance and a need are used to rank performances that require an intervention. This working method can provide indications for more isolated measures spread across the building. A final approach, not based on functional values but on the fit with expected performances, is to prioritize locations according to low score concentrations in a formal evaluation.[8]

Once the locations or performances are prioritized, corrective actions can be formulated. To determine the appropriate measures, one can make use of the content of performances and needs, of information from the scores and related problems in the evaluations (including problems revealed in a special program), and of possibly available exact measures and correlated data (see Sect. 3.4.2). By examining performance-need combinations at these locations that are more important and have a lower satisfaction score, it is often immediately clear where to intervene, what the problems are, which measures are necessary and why this is the case (owing to the fact that the evaluations are narrowly tailored to the object). The hallway in Table 4.4, for example, has a rather low functional value (53,6) and a high average importance score (7,0). Therefore, this location has a certain priority. An examination of the average satisfaction and importance ratings of the five combinations reveals that the main problem lies with the spy hole in the front door (a high importance and a low satisfaction). The open question may show that the spy hole is too high up to be used properly, so the first measure can be to lower it.

Finally, the functional values of locations or a building can be calculated at a higher aggregation level of user needs to be used as benchmarks (see Sect. 3.4.2). For this purpose, the combinations belonging to an overarching state are added together (e.g. all combinations regarding thermal comfort or social safety for a location or the building), after which the functional value for this collection of combinations is established. These values can be used to evaluate the current building and they can

[8] These options are based on experiences with USE, except for the last option, which is an assumption.

find their way into databases as references for comparing and designing buildings. This also applies to other information (e.g. needs, problems and possible solutions).

References

Alexander C (1977) A pattern language: towns, buildings, construction. Oxford University Press, Oxford

Coolen H, Hoekstra J (2001) Values as determinants of preferences for housing attributes. J Housing Built Environ 16:285–306

Cooper Marcus C, Sarkissian W (2000) Housing as if people mattered: site design guidelines for low rise, medium density family housing, 5th edn. University of California Press, Berkely

Gifford R, Steg L, Reser J (2011) Environmental psychology. In: Martin P, Cheung F, Knowles M, Kyrios M, Littlefield L, Overmier J, Prieto J (eds) IAAP handbook of applied psychology. Blackwell Publishing Ltd., Chichester, pp 440–470

Gutman J (1982) A means-end chain model based on consumer categorization processes. J Marketing 46:60–72

Hershberger R (2002) Behavioral based architectural programming. In: Bechtel R, Churchman A (eds) Handbook of environmental psychology. Wiley, New York, pp 292–305

Kujala S (2003) User involvement: a review of the benefits and challenges. Behav Inf Technol 22:1–16

Reynolds T, Gutman J (1988) Laddering theory, method, analysis, and interpretation. J Advert Res 28:11–31

Taxén G (2004) Introducing participatory design in museums. In: Clement A, de Cindio F, Oostveen A, Schuler D, van den Besselaar P (eds) Proceedings of the eighth conference on participatory design. Artful integration: interweaving media, materials and practices, vol 1. Toronto, Ontario, Canada, pp 204–213

Chapter 5
Application

Abstract USE can be employed for various purposes, such as drawing up programs of demands for new designs or renovation projects, doing post-occupancy evaluations, screening preliminary designs for design reviews, describing processes of use in groups and buildings, and benchmarking buildings. In the previous chapter, the methodology of USE was outlined. This chapter illustrates the practical application of the method. In addition, adaptations are discussed that may be required for a good result. On the one hand, the method has certain anchors that provide clarity and reliability, such as the conceptual framework and the protocol, while on the other hand, it should be flexible in order to be able to respond to the circumstances in a project. The examples show the kind of choices that sometimes must be made and options that are available.

Keywords User needs analysis · Program of demands · Formal evaluation · Functional evaluation · Functional value · Adaptations

5.1 Program of Demands

An example of this type of application is a program of demands for a new complex of dwellings for independently living elderly people. Preparing a program of demands involves a user needs analysis, which is followed by the development of the program itself. These parts are described in Sect. 4.1 and Sect. 4.2. The user needs analysis includes the definition of the object of research, the identification of user groups, and the inventory of user needs of each group (and other information) using the protocol. In this example, a more basic situation is assumed first, with the new dwellings as objects of research and only one group of users, namely the future residents who registered for the dwellings. These registrants are interviewed about their present housing conditions, because it is desirable that the process of use remains largely the same in the new dwellings, while problems in the old situation are to be avoided in the new design.

In the protocol, supplementation and concretization are used. Attention is also paid to the level of aggregation of the user needs. Table 5.1 provides an impression of the supplementation in a part of the completed protocol, with fictitious data and

Table 5.1 Example of supplementation with hallway as access point

1. Locations	2. Activities	3. (Add.) States	4. Add. Activities	5. Add. Locations	6. Problems now	7. Problems future
hallway	enter house	being mobile	enter w. wheelchair	hallway		
			use handrail	stairs		handrail gets loose
	receive guests	social contact	comb hair	hallway		
				bathroom		
			let guests stay over	spare bedroom		
	hang up coats	tidiness	store dog's toys	hallway		
			put away groceries	kitchen	little storage space	
	lock front door	social safety	look who's at door	hallway	spy hole too high up	
	wipe feet	hygiene	put away shoes	hallway		
			take out garbage	kitchen		
		physical safety	use night light	landing		long walk, too heavy
	read meters	being informed	read newspaper	living room		
			watch tv	living room		

with the hallway as the access point (see Appendix A). The activities and states seem fairly common. However, the purpose is not to detect anything unusual, but to approach the completeness of the set of user needs. At first, 6 activities are registered at this location, with 7 related states. Supplementation through the states increases the number of activities to 11 in the hallway plus 8 in other locations (in part A of the protocol). As a result, this method adds between 19 and 26 user needs to the total set, depending on whether or not states are regarded as additional needs. The same occurs for the other locations, and the number increases even further in parts B, C and D of the protocol in which states, problems and general needs are access points (some problems are visible in Table 5.1 since it is part of a completed protocol). Supplementation appears to be a useful tool to elaborate the set of needs.

Concretization should lead to well formulated needs. In the example, this seems to be mostly the case. Some of the topics could be described more precisely, such as the nature of the problems in storing the various items and in observing visitors (the height of the spy hole). Likewise, for some activities, a lower level of aggregation is desirable, such as for receiving guests and disposing of garbage (the more specific activities they consist of and the exact activities people have problems with). In order to create a suitable design and avoid problems, a designer should, of course, have a proper understanding of those matters. These are also issues to be aware of in the content analysis that leads to the final list of needs (see Sect. 4.1.3).

The development of the program begins with performance linking. In the example, needs from their own interview are returned to the respondents with a request to name the required performances for each with suitable aggregation levels, solution spaces and possibly a location (see Sect. 4.2 and Appendix A). The decisions are reviewed by the guiding team using the control questions. The resulting functional demands are also screened by the team to identify possible conflicts and opportunities for combinations in a design, after which they are prioritized and classified in the program.

The program has the form of a database with one record for each demand. Table 5.2 shows a selection of 10 records for the hallway. In the example, a record has 8 fields containing record numbers, user needs (activities), performances, locations, function and performance categories, priorities and remarks (specifications and suggestions for avoiding problems). The function categories are a classification of needs into their corresponding overarching states (as in the overview of general needs in Appendix A). Performance categories refer to: space (sizes), layout, presence of spatial elements, finishes and materials, installations, decorations and furnishing, flexibility and adaptability, and appearance and experiential value.

In the database, several helpful selections and cross-sections can be made, partly by means of the function and performance categories. For example, sorting by performances can show how they are related to different needs. This can put the designer on the track of solutions that meet several needs simultaneously. A classification based on function categories can be used for benchmarking (see Sect. 3.4.2 and Sect. 4.3.2). Another option is a sorting by performance categories, then by performances and by locations. This may be practical for creating layers in Cad programs or for BIM, for

Table 5.2 Example of database with functional program of demands

Nr	FC	User need (motive)	Performance	Location	PC	P	Remarks / specification
047	C	wipe feet	recess for standard doormat inside	hallway	D	8	doormat outside: danger tripping
134	I	receive guests	automatic light outside	hallway	E	7	
137	I	receive guests	place for a mirror near front door	hallway	F	6	
153	J	let guests use toilet	separate toilet	hallway	E	9	other toilet in bathroom
234	N	look who is at the door	spy hole in front door	hallway	F	8	combined with intercom
267	O	lock front door	easy-to-use locks	hallway	E	8	e.g. combination lock, for seniors
409	W	enter and leave house	space for an umbrella stand	hallway	A	5	
416	W	enter and leave house	low or no threshold	hallway	D	8	
434	W	walk in the house	possibilities for handrails	hallway, corridor	F	5	no obstacles possible handrails
526	Y	put away shoes	storage space for five pairs	hallway	A	6	e.g. shoe shelf or cabinet

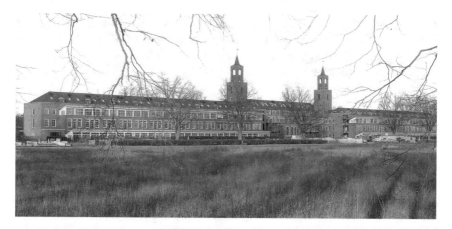

Fig. 5.1 De Klokkenberg near Breda (the Netherlands)

example, because all the demands with spatial or with installation characteristics of a location can be brought together.[1]

The above example is a simplified account of an existing case. It involved the redevelopment of a former clinic and sanatorium into apartment units and houses for independently living elderly families (de Klokkenberg; see Fig. 5.1). The program of demands was for the apartment units (Heijs 2010). There were three different scale levels: the apartments, apartment buildings and the environment with general facilities. Thus, the protocol consisted of three questionnaires. In addition to the future residents, there were other user groups, such as management and maintenance staff and various service providers.

It is not uncommon that adaptations to a research design are required due to the circumstances. As in the example above, the future residents were represented by the families who registered for an apartment. Normally, a user needs analysis for residents would focus on that group because of the reasons mentioned (i.e. similar processes of use and avoidance of present problems). However, in this case, the registrants had their own dwellings distributed over the city and had no experience of living in a complex like this. Their needs and problems could be different from those in the future apartments. Besides, the other groups were still non-existent, so that their representation had to be established as well.

To get a grip on this, parallel user needs analyses were conducted in two facilities that resembled the new complex. Among residents, a total of 81 families were questioned and interviews were held with members of the other groups. A comparison of the results of the three groups of residents (the registrants and the parallel groups) made it possible to compile a set of user needs that did justice to the present processes of use and was also applicable in the intended project. As in the example above, an inventory of required performances was made, based on the needs of residents and

[1] In the examples of needs and demands in Sect. 5.1 and Sect. 5.2, a number of imperfections have been intentionally included for illustration purposes that obviously do not occur in the real program.

the interviews with other groups, and a program was drawn up with 719 demands in the format described in Table 5.2 (532 for the apartments, 87 for the apartment buildings and 100 for the environment). This program took into account both existing and future problems as much as possible.

5.2 Evaluation

For post-occupancy evaluations, ideally, a program of demands serves as the starting point. If the demands contain clear and objective criteria, it is possible to perform both a formal and a functional evaluation. Otherwise, only a functional evaluation can be carried out. This is also true if there is no (suitable) program. In that case, the functional evaluation is based on a special program (see Table 4.1). This section illustrates evaluations using a normal and a special program.

In most examples of demands in the previous section, there are objective criteria for a formal evaluation, so both types are possible (see Table 5.2). Which of the two formats for a formal evaluation is preferred depends on the situation and the content of the demands (see Sect. 4.3.1). Sometimes the choice is obvious. In the initial questions for the hallway below, the first format is used because these demands do not contain values that may call for a specific evaluation. For the next three demands, this could possibly be the case if emphasis were placed on the *sizes* of a recess and a storage space (with *a size of a standard mat* and *a quantity of five pairs of shoes* as values) and the *functioning* (or the *type*) of the outdoor light (with the value *automatic*). All of these questions can be answered using concrete measurements (i.e. a visual inspection of the building).

formal evaluation, format 1: to what extent is …

 − *a recess for a standard doormat inside* realized?
 − *an automatic light outside* realized?
 − *a separate toilet* realized (next to the one in the bathroom)?
 − *a spy hole in the front door* realized?
 − *storage space for five pairs of shoes* realized?

formal evaluation, format 2: to what extent does …

 − *the size of the recess inside* fit *the size of a standard doormat*?
 − *the working (or type) of the light outside* fit the condition of being *automatic?*
 − *the size of the storage space* fit *a quantity of five pairs of shoes?*

The criteria for four other demands also seem to be objective *(place for a mirror near front door, space for an umbrella stand, low or no threshold, possibilities for handrails),* although as such they are not assessable. This calls for additional knowledge, for example, about the sizes of the desired mirror and umbrella stand, a standard for the height of thresholds in view of accessibility and requirements for attaching

handrails. This knowledge would allow the questions to be answered in a formal evaluation (for the threshold criterion there should be one value instead of two).

Lastly, the criterion in the demand *easy-to-use locks* is subjective. While the examples in the program do provide an indication of how it might be interpreted, ultimately the users will be in the best position to judge this from their own experience in the functional evaluation. Questions in that evaluation may have the following structure (using applicable attributes where appropriate, because it is important to make sure that the realized performance, and not the expected performance or value, is assessed).

functional evaluation: how important is .../how satisfied are you with ...

- *the working (or type) of the light outside* for *receiving guests?*
- *the spy hole in the front door* for *looking who's at the door?*
- *the height (or presence) of the threshold* for *entering/leaving the house?*
- *the size of the storage space* for *putting away shoes?*
- etc.

Of further relevance for the content of the questionnaire are the potential problems to be avoided in the design. In this case, these were recorded in the user needs analysis (see Table 5.1). An example of such a problem is that in the previous situation the spy hole in the front door is too high up.

If both a formal and a functional evaluation have been conducted, then in addition to the usual analyses (see Sect. 4.3.2), the findings can be compared. These may point in the same direction if the program is properly aligned with the process of use. There may be discrepancies as well. In this case, for example, the formal evaluation shows that the demand for a spy hole in the front door was satisfied. At the same time, the functional value of the hallway is low. The last column in Table 4.4 shows that this is mainly due to the fact that the spy hole does not satisfy the need to see who is at the door. According to the open question, it is still too high. Apparently, the problem, which was known from the previous situation, has not been corrected in the new design. This is a consequence of the issue being ill-defined in the protocol (not an exact height in Table 5.1) so the demand in the program is incomplete. The omission can lead to increased failure costs because of necessary modifications or a replacement of the doors. The opposite is also possible: a realized performance that is not formally correct but does qualify in a process of use. In that case, demands can be too strict (see Sect. 3.4.2). Such discrepancies may reflect inadequate criteria, which can therefore be discovered through the use of both evaluations.

If there is no suitable program, a special program can be created post-hoc, using the protocol, in which user needs are linked to locations. This is the basis for a functional evaluation (see Sect. 4.3.1). The questions would take the following form (derived from the hallway example in Table 5.1).

functional evaluation (special): how important is .../how satisfied are you with ...

- *the hallway* for *receiving guests?*
- *the hallway* for *looking who's at the door?*

– *the hallway* for *entering or leaving the house?*
– *the hallway* for *putting away shoes?*
– etc.

Questions with a low satisfaction score are followed by an open question about the causes. This allows problems to be identified such as a spy hole that is too high, an inconvenient threshold or too little storage space. With the importance and satisfaction scores, functional values of locations such as the hallway or of the entire dwelling can be calculated (optionally also for different groups of users; see Sect. 4.3.2). Lower functional values can be traced to the underlying problems, through the answers to the open-ended questions, so that specific measures can be applied (such as repositioning the spy hole or expanding the storage space).

Post occupancy evaluation research also sometimes requires adjustments. The next two examples involve single evaluations of university buildings in the operational phase: the Chemistry department and the Student sport center of the University of Technology in Eindhoven (see Figs. 5.2 and 5.3). For both buildings, a formal evaluation was not possible because a suitable program was missing, so a functional evaluation was carried out based on a special program. For this purpose, members of the relevant groups were interviewed using the protocol (Heijs 2009, 2012).

The situation in the buildings was extremely complex because there were many different spaces and processes of use, and due to their combination, a large number of different groups that needed to be taken into account in the evaluation. In the chemistry department, groups were potentially large enough and with a stable composition to carry out a functional evaluation using a digital survey. This was different at the sport center. There were more than 30 types of sports, often using different locations and facilities. Moreover, for each sport the teachers/trainers and the athletes constituted different user groups. Due to the combination of types of sports, locations and functions, there were not only many different groups, but also a large number

Fig. 5.2 Chemistry department University of Technology Eindhoven

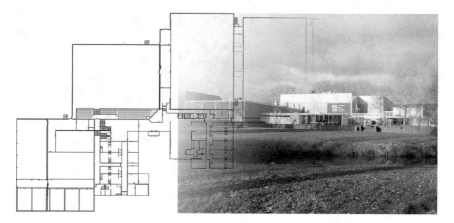

Fig. 5.3 Student sport center University of Technology Eindhoven

of groups with only one or two members (teachers and trainers). The groups could not be merged because of their dissimilar composition and there was a significant turnover within the groups of athletes, which would make the organization of a digital survey impractical.

Therefore, it was decided to build on the results of the preliminary study of the sport center instead of using a survey. In the interviews, problems of the groups with the various locations were sufficiently covered. To add the evaluation scores, the combinations of locations and user needs from the interviews were returned to the respondents with a request to provide each combination with ratings of importance and satisfaction. Most of the teachers/trainers had participated in the interviews, so the request yielded a useful result for those groups. This could not be confirmed for athletes, because the actual group was larger than the group that participated in the interviews and because of the turnover in that group since then. However, the scores were broadly in line with the teacher/trainer ratings, indicating a certain reliability. This experience reveals that, in the unusual situation where the presence of many small groups interferes with a survey, such a procedure can be a possible (though perhaps less desirable) solution.

5.3 Other Applications

Post occupancy evaluations and the manufacture of programs of demands are more common topics. Other applications are less customary. Some are relatively straight-forward, such as stand-alone user needs analyses to map processes of use in support of various goals. An example is a study of the added value of home automation for independently living elderly people with a mild need for care. A graduation project

Fig. 5.4 Entrance Hall GGzE Eindhoven (M. Biezen and J. Kontou, 2019)

was conducted to see how functions of this technology could fit in with the processes of use of two groups of users: the elderly and care workers.[2]

The research design can also be more complex, such as when the method is used in a renovation project. The first step in the project may consist of an evaluation of the situation to identify problems, or confirm suspicions of the problems that gave rise to the renovation plan. If there is a suitable program, that would be the basis for this evaluation. Otherwise, a special program is required to allow a functional evaluation. Then, a program of demands can be created for the measures to be taken.

This general procedure can be modified and adapted to the situation and the wishes of the client. For example, in a more extensive form, a second evaluation can be carried out after the renovation to establish whether the measures had an effect. The results of this follow-up (such as evaluation scores, functional values and problems) are compared with the results of the first evaluation. Another adaptation involves the program of demands for the measures in the renovation. This can be an elaborate program or a limited program with only the demands that relate to the problems found. The latter may be cheaper and easier to implement, but there is a risk that effects of the measures are overlooked for aspects that are not included in the program.

The more extensive version, with a first functional evaluation based on a special program and a second evaluation after the renovation, and with a limited program of demands, was used in a study on the improvement of the appearance of a clinic's reception area regarding, among other things, the amount of control and privacy (see Fig. 5.4). Respondents in the pre- and post measurement were two different, matched groups of visitors and a single group of staff members. A comparison of the separate

[2] The method was used in several graduation projects on a variety of topics such as the renovation of rental housing for elderly people, nursing homes, portfolio management of municipal buildings, military offices, the housing of young adults with intellectual disabilities and the design review of a future Olympic village (see part 3 of Appendix A for a list containing some of these graduation projects including the study mentioned here).

scores and the functional values of the area and its spatial components in the two assessments clearly showed the effects of the measures.[3]

As already noted, USE can in principle be employed for other objects of different types and scales. The condition is that one or more distinct user groups and specific processes of use are involved. To illustrate, Appendix C contains some reflections on an application in dealing with problem neighborhoods.

References

Heijs W (2009) Gebruikswaardenonderzoek Studentensportcentrum (Evaluation research Student sport center). Research report. Interface, University of Technology, Eindhoven

Heijs W (2010) Een programma van eisen voor de Klokkenberg: een toepassing van USE (A program of demands for the Klokkenberg: an implementation of USE). Research report. Interface, University of Technology, Eindhoven

Heijs W (2012) Gebruikswaardenonderzoek Scheikundegebouw (Evaluation research Chemistry department). Research report. Interface, University of Technology, Eindhoven

[3] Heijs W (2019). Entreehal GGzE (Entrance hall GGzE). Research report. Unpublished contract research.

Chapter 6
Review

Abstract Now that the method has been described, a comparison can be made with other approaches by reviewing the main differences and advantages. This includes the background, the methods and the type of results. In addition, possible future developments are discussed in terms of improvements of the implementation of USE and an expansion of its functionality.

Keywords User needs · Performances · Program of demands · Post occupancy evaluation · Functional value · Benchmarking

6.1 Comparison

A notable difference with other approaches is the theoretical anchoring of USE in the congruence model of P-E fit and the related systematic nature of the method. This is reflected in the descriptions of the concepts and the procedures, which are more specific and structured. Based on this model, an explicit distinction is made between a personal and an environmental dimension, in the form of user needs and performances, which converge in the functional demands. User needs are defined as activities and states rather than elements and attributes, which in this context are regarded as performances. While these meanings are sometimes encountered in other approaches, the main functions of user needs are different in the present framework. They form the basis for the deliberate and organized search for matching performances (to which the user needs precede as an extra layer). They are used as motives in the functional demands to promote a proper interpretation of performances. In addition, they act as criteria in functional evaluations, so realized performances can be checked against the process of use, even if the performances are subjective or less exact.

The user needs analysis has several distinguishing features. The needs of all relevant user groups of a building (or object) are analyzed instead of only those of users in the core process. The analysis covers a wide range of physiological, social and psychological needs. It has a fixed protocol that steers a complex search process, gradually elaborates and charts the process of use, and produces a comprehensive, finite and surveyable set of needs. These needs are less transient than needs in terms

of elements or attributes, so they are a stable frame of reference for design, periodic evaluation and benchmarking. At the same time, this analysis is flexible enough to yield results that reflect the diversity of human needs.

With the needs as a guide, the search for performances can return a more complete collection as well. The performances have a broad scope. They can be qualitative or quantitative, objective or subjective, and technical, functional or perceptual in nature. Nevertheless, the set of performances is concise, because of the guiding effect of the needs and an emphasis on the essential character of the performances. Consequently, a program of demands is potentially also more complete and adapted to the actual use of the building. The program is functional, intended for the design phase and not for construction as in some approaches. The format of demands is not as usual, because a performance is always combined with a user need as a motive. Knowledge of motives can facilitate proper decision making in the design process. The combinations of performances and needs in the demands represent parts of the interaction between users and the building while the program reflects the interaction or process of use as a whole.

In principle, the format of the demands (with expected performances and needs as potential criteria) enables two complementary evaluation types. In the first type, a formal evaluation, realized performances are compared with expected performances as in other approaches. This requires criteria in the form of objectively measurable expected performances. If objective criteria are absent, a formal evaluation is impossible. Using standard lists of criteria (as some methods do) is not an option, because evaluations in USE are tailored to the object. The second type is a functional evaluation, in which realized performances are tested against the process of use with the user needs (motives) as criteria. This is almost always possible. Even without suitable demands, a functional evaluation can be carried out with a special program. In terms of BPE, evaluation research in USE is mainly investigative with some diagnostic elements (identification of the causes of problems). Indicative research is not a part of USE.

Another distinctive aspect is the functional value, a quantitative measure of the usability of a building or building part (or the degree of fit between realized performances and user needs). These values are employed in the evaluation of buildings and the prioritization of measures to increase the fit and solve problems between buildings and their users. The specificity of the evaluation and the functional values allow for the development of measures that are well suited to the situation, which can make them more effective. Functional values based on a higher level of aggregation of the needs involved (states), may be usable as benchmarks to rate the effects of measures and compare buildings.

USE can be considered as a method that fits the domain of social design. The input of users, the focus on the fit between needs and performances, and the more complete program of demands can improve the interaction between users and their environment and prevent adverse effects of less desirable design decisions and failure costs. The knowledge gained with this method can enable designers to create solutions that are compatible with the paradigm of social design and may provide them with a drive to adopt and use the method themselves.

6.2 Future

Some plans for the future relate to improvements of the implementation of USE. Others concern the expansion of the functionality. An issue that was already discussed is that initially, a transition from a traditional view of user needs to the perspective in USE can take some effort. This is now handled by training and by checking the interviews. The thoughts are for a software-based solution, which can also facilitate the ease and speed of user needs analyses, namely to computerize the protocol with some basic artificial intelligence. As a result, it will not only be possible to monitor the process but also to control the quality of the output. In the same way, a search for matching performances may be streamlined. One could think of a search engine that uses the sources described in Sect. 4.2.1 and suggests solution spaces that do not impede the freedom of choice of the designer. Perhaps this could be accomplished in collaboration with approaches that have a proven expertise with regard to performances (e.g. performance-based building). Moreover, a decision support system could be developed for the choices that have to be made in evaluation research, in which the appropriateness of decisions in earlier research can be taken into account.

Performing a user needs analysis or evaluation with USE takes time. The research generally pays for itself by the insights gained and the problems that are prevented or solved as a result. Nevertheless, the completion of a questionnaire during the evaluation can be time-consuming, especially in the case of larger buildings and organizations. This is somewhat reduced by conditional branching, but other options should be explored to reduce the effort of respondents. One possibility is to not only divide the location and group specific questions over different respondents (as in conditional branching), but also questions that apply to all. It may be possible to use several groups with an identical and representative composition, each of which is presented with a part of the questionnaire. Sometimes questions regarding the importance of fit may be skipped. If, in the case of a special program, a location is linked to an inherently associated activity (or need, such as the entrance for *entering*), the importance of the fit may not have to be asked. It could be assigned the same (maximum) score for all.

Another aspect deserving attention is actually an extension of the number of topics in evaluations. If it does not take too much extra time and effort, the functional evaluation could include some questions about underlying design assumptions concerning the effects of performances on patterns of use of certain locations. This not only widens the scope of the evaluation, but also creates an opportunity to assess the validity of these assumptions, based on related satisfaction scores, and thus to gather more knowledge about the interaction between users and buildings.

In addition, the scope of the method itself can be extended. The option of using functional values to set benchmarks, as mentioned above, should be tested in practice. Another point that has been made is that the method is, in principle, suitable for objects other than buildings. This suitability may be checked, for example, by using it as an auxiliary tool when renovating problem neighborhoods (in Appendix C). Findings obtained with USE should be included in a database so they can be

accessed in future studies with this method or in another context. This would comprise general user needs and needs of particular groups of users of prevalent building types, examples of programs of demands that could provide suggestions in the search for performances, and building category related benchmarks. This database should be accessible on-line so it can help to close information gaps.

Appendix A
Instruments

This appendix contains the instruments that are described in chapter four:

1. Instructions and questions of the user needs analysis protocol
2. Examples of sheets of the user needs analysis protocol
3. Examples of needs for sheet 3 of the user needs analysis protocol
4. Instructions and example inventory of performances among users
5. Sheet for the calculation of functional values and related measures

A.1 Instructions and Questions of the User Needs Analysis Protocol

A.1.1 Instructions

These are general instructions that can be included in sheet 1.

- fill in the respondent details on sheet 1; save the file using the respondent number.
- use a plan with location numbers or names (decide beforehand which locations are included, e.g. whether or not wall closets, balconies, outdoor spaces, etc.).
- explain the intention of the interview.
- pose questions for either the person or a person as a group member (small samples).
- fill in 'object' and words in *italics* in the questions during the interview (the names of objects, locations, activities, states and problems).
- first listen to the answers and then type them in; it may be faster to use abbreviations and work them out immediately after the interview (e.g. mb = master bedroom).
- put answers in the appropriate columns (indicated by the numbers of the questions).
- pay attention to concretization and aggregation levels; keep asking if necessary.

- in enumerations: keep asking until all locations, activities, states or problems have been mentioned; if necessary, ask for physiological, social and psychological aspects.
- unless indicated otherwise, complete a column before going to the next question.
- keep answers that are connected in the same or in the directly following rows; it may be necessary to add new rows in between using shortcut keys (set these first).
- if new information is provided that is not an answer to a question, add this in new rows and in the appropriate columns (all information may be valuable).

A.1.2 Questions

The questions may or may not be visible on the sheets (see below in A.2.2 and A.2.3). There can be one workbook for an entire object or separate ones for different parts, such as the dwellings, the building and the surrounding area in case of multi-family houses. The letters L, A, S and Pr correspond to locations, activities, states and problems respectively and the arrows in between letters indicate search directions. Dashes mark comments. Texts in italics between parentheses contain instructions.

A. **access from locations and activities (sheet 2)**.

1a. column 1 (L)
 Which locations (rooms, spaces) do you (does your group) use in 'object'?
 Please state the name or the number on the map.
 – locations are a good starting point because they are easy to think of.
2a. column 2 (L → A; per *location*, point out on map)
 Which activities do you (does your group) perform in *location*? (or: What are you mainly doing here? What else do you do here?).
 – in some locations there is only one activity, in others there may be more.
 (when column 2 completed: tell respondent some of the next questions may seem a bit unusual or similar to previous ones, but this has an intention; if needed, give a global explanation of the cognitive structure).
3a. column 3 (A → S; per *activity* and *location*)
 Why do you (does your group) perform *activity* (do that) in *location*? Does *activity* in *location* have any other purposes? *(repeat until no more states for this activity; sometimes an example is needed; let respondent try first; if the state is self-evident and respondent has trouble giving an answer, fill in a general state and check if person agrees; e.g. going to toilet for physical health; see general states on sheet 3 for examples; after states for this activity go to 4a).*
 – more activities may belong to the same state.
4a. column 4 (S → A; per *state*)
 What (else) do you (does your group) do in 'object' for *state*?
 (all additional activities per state; after state go back to 3a for next state; after additional activities for final state go to 5a).

5a. column 5 and 1 (A → L; per additional *activity*)
 Where does *activity* for *state* take place?
 *(use plan to find correct location name or number; if new location, also add
 to column 1; complete for all additional activities in column 4).*
 – may be same location or others that one previously forgot to mention.
2b. column 2 (L → A; per additional *location* in column 1)
 What (else) do you (does your group) do in *location*?
 (complete for new locations; starting in same row as location column 1).
3b. column 3 (A → S; per additional *activity* and *location* in column 2 and 1)
 Why do you (does your group) perform *activity* (do that) in *location*?
 (note states; usually there are no new states; if there are, repeat 4a, 5a, 2b).

B. access from states (sheet 2).

– now that the concept of states is clear, they are usable as new access points.

3c. column 3 (S)
 (mention former states to make them more prominent).
 Are there other states you (your group) pursue(s) in 'object'? Which states?
 (additional states on new rows).
4b. column 4 (S → A; per additional *state*)
 What do you (does your group) do in 'object' for *state*?
 (add activities starting in row of state 3c).
 – new states may involve activities mentioned before and also new ones.
5b. column 5 and 1 (A → L; for each additional *activity* for additional *state*)
 Where does *activity* for *state* take place?
 (complete for new activities; if new location, also add to column 1).
 – may be in formerly mentioned locations or still new ones.
2c. column 2 (L → A; only for additional *location* in column 1)
 What else do you (does your group) do in *location*?
 (complete for new locations).
 – this may reveal new activities or older ones.
3d. column 3 (A → S; per additional *activity* and *location* in column 2 and 1)
 Why do you (does your group) perform *activity* (do that) in *location*?
 (note states; usually there are no new states; if there are, repeat 4b, 5b, 2c).

C. access from problems (sheet 2).

The next questions are about problems you (your group) may experience in 'object';
that may concern big problems but smaller ones may also be of interest. (optionally:
those problems can be related to the building but other problems may also be relevant;
in that case delete 'due to object' in the next questions).

– sometimes a relation with the building is not evident at first but becomes clear later.

– problems may yield new activities (needs) and are needed for POE (so two results).

6a. column 6 and 2 (Pr, L → A; per *location* in column 1)
 Are there problems with activities in *location* due to 'object'? What are those
 problems?
 *(new activities in column 2 and problems as a whole in column 6; causes and
 relation problem—building must be clear).*
7a. column 7 and 2 (Pr, L → A; per *location* in column 1)
 Do you (does your group) expect other problems with activities in *location*
 due to 'object' in the future? What are those problems?
 *(new activities in column 2 and problems as a whole in column 7; causes and
 relation problem—building must be clear).*
6b. column 6 and 2 (Pr, L → A; per *location* in column 1)
 Are there activities that you (your group) want(s) to perform in *location* that
 are not possible there? What are those activities?
 *(new activities in column 2 and as impossible activity plus reasons in column
 6).*
6c. column 6 and 2 (Pr → A; remaining problems with 'object' in general)
 Do you (does your group) have any other problems in 'object'? What are those
 problems?
 *(start new row after last entry; new activities in column 2 and problems as a
 whole in column 6; causes and relation problem—building must be clear).*
 – the type of problems is now evident, so this question should be clear.
7b. column 7 and 2 (Pr → A; remaining problems with 'object' in general)
 Do you (does your group) expect other problems in 'object' in the future?
 What are those problems?
 *(start new row after last entry; new activities in column 2 and problems as a
 whole in column 7; causes and relation problem—building must be clear).*
6d. column 6 and 2 (Pr → A; for 'object' in general)
 Are there activities that you (your group) want(s) to perform in 'object' that
 are not possible there? What are those activities?
 *(new activities in column 2 and as impossible activity plus reasons in column
 6).*
1b. column 1 (A → L; per new *activity* from problem 'object' now, future)
 Where does/will *activity/problem* happen?
 (complete for new activities in column 2 from 6c, 7b, 6d).
4c. column 4 (L → A; only for additional new *location* in column 1)
 What else do you (does your group) do in *location*?
 (complete for new locations in column 1 from 1b).
 – this may reveal new activities or older ones.
3e. column 3 (A → S; per new *activity* and *location* in column 2 and 1)
 Why do you (does your group) perform *activity* (do that) in *location*?
 (note states; usually there are no new states; if there are, repeat 4b, 5b, 2c).

D. **access from general needs (sheet 3)**.

– relevance of known needs for this target group and additional problems.

1. column 1 (S)
 (introduce first state <u>not yet mentioned</u> on sheet 2).
 Is this important for you (your group) in 'object'?
 Is this state somehow related to 'object'? *(if not, go to next state).*
 (complete next questions for this state before going to following state).
2. column 2 (S → A; for each relevant *state*)
 What do you (does your group) do in 'object' for *state*?
 (make precoded activities bold or add new row in case of new activity; also note activities that were already mentioned on sheet 2; maybe examples are needed from column 2; complete the list of activities before next question).
3. column 3 (A → L; for each *activity* for *state* not mentioned on sheet 2)
 Where does *activity* take place?
4a. column 4 (A,L → Pr; per *activity* and *location* in column 2 and 3)
 Are there problems with *activity* in *location* due to 'object'? What are those problems?
 (relation problem—building must be clear; needed for POE).
5. column 5 (A,L → Pr; per *activity* and *location* in column 2 and 3)
 Do you (does your group) expect problems with activity in *location* due to 'object' in the future? What are those problems?
 (relation problem—building must be clear; needed for POE).
4b. column 4 (S,L → Pr: for *state* and *location* in column 1 and 3)
 Are there activities that you (your group) want(s) to perform for *state* in *location* that are not possible there? What are those activities?
 (describe activities as impossible plus reasons in column 4; needed for POE; repeat questions 1 to 4b for next state).

A.2 Examples of Sheets of the User Needs Analysis Protocol

Sheet 1 contains the respondent details and possibly a copy of the general instructions. In sheets 2 and 3, by using split panes, questions and specific instructions can be shown at the top, with columns for the answers below them. The panes can be scrolled separately. The illustrations of the sheets in A.2.2 and A.2.3 are reduced in size; the content is similar to A.1.2 above.

A.2.1 Sheet 1 Respondent Data

Number	
Group (code)	
Interviewer	
Date	

Instructions

A.2.2 Sheet 2 Regular Supplementation

1a. Which locations (rooms, spaces) do you (does your group) use in 'object'? Please state the name or the number on the map. (complete column)

2a. Which activities do you (does your group) perform in *location*? (point out on map; complete column)

3a. Why do you perform *activity* in *location*? Why do you (does your group) do that? (if self-evident and no answer, fill in general state and check)

 Does *activity* in *location* have any other purposes? (repeat until no more states for that activity; then go to 4a)

 4a. What else do you (does your group) do in 'object' for *state*? (all activities per state; after state go to 3a for next state; after final state to 5a)

5a. Where does *activity* for *state* take place? (complete for all additional activities in column 4; use plan; if new location, also add to column 1)

2b. What else do you (does your group) do in *location*? (complete for new locations; start in same row as new location column 1)

3b. Why do you (does your group) perform *activity* (do that) in *location*? (complete for new activities and locations in column 2 and 1; note states; if new states repeat 4a, 5a, 2b)

3c. (mention former states) **Are there other states you (your group) pursue(s) in 'object'? Which states?** (add in new rows column 3; complete states)

4b. What do you (does your group) do in 'object' for *state*? (add to column 4 starting in row of state 3c; complete all activities for all additional states)

5b. Where does *activity* for *state* take place? (complete for all new activities; if new location, also add to column 1)

2c. What else do you (does your group) do in *location*? (complete for new locations in column 1)

3d. Why do you (does your group) perform *activity* (do that) in *location*? (complete for new activities and locations in column 2 and 1; note states; if new states repeat 4b, 5b, 2c)

The next questions are about problems you (your group) may experience in 'object'; that may be big problems but also smaller ones. Optionally: problems can be related to the building but others may also be relevant. (in that case: delete 'due to object' in next questions)

6a. Are there problems with activities in *location* due to 'object'? What are those problems?
 (for each location in column 1; new activities in column 2 and problems as a whole in column 6; causes and relation problem-building must be clear)

7a. Do you (does your group) expect other problems in *location* due to 'object' in the future? What are those problems?
 (for each location in column 1; new activities in column 2 and problems as a whole in column 7; causes and relation problem-building must be clear)

6b. Are there activities that you (your group) want(s) to perform in *location* that are not possible there? What are those activities?
 (for each location in column 1; new activities in column 2 and as impossible activity plus reasons in column 6)

6c. Do you (does your group) have any other problems in 'object'? What are those problems?
 (new row after last entry; new activities in column 2 and problems as a whole in column 6; causes and relation problem-building must be clear)

7b. Do you (does your group) expect other problems with 'object' in the future? What are those problems?
 (new row after last entry; new activities in column 2 and problems as a whole in column 7; causes and relation problem-building must be clear)

6d. Are there activities that you (your group) want(s) to perform in 'object' that are not possible there? What are those activities?
 (new row after last entry; new activities in column 2 and as impossible activity plus reasons in column 6)

1b. Where does/will *activity* (problem) happen? (complete for new activities in column 2 from 6c, 7b and 6d)

4c. What else do you (does your group) do in *location*? (complete for new locations in column 1 from 1b)

3e. Why do you (does your group) perform *activity* (do that) in *location*? (complete for new activities and locations in column 2 and 1; note states; if new states repeat 4b, 5b, 2c)

1. Locations	2. Activities	3. (Add.) States	4. Add. Activities	5. Add. Locations	6. Problems now	7. Problems future

A.2.3 Sheet 3 General and Known Needs

1. (introduce state not mentioned on sheet 2) **Is this important for you (your group) in 'object'? Is this state somehow related to 'object'?** (if not, go to next state; if yes, complete questions for this state before next state) 2. **What do you (does your group) do in 'object' for state?** (for each relevant state; make precoded activities bold or add new row in case of new activity; also note activities already mentioned on sheet 2; maybe examples needed from column 2; complete activities before next question) 3. **Where does activity take place?** (for each activity mentioned in 2 for state not mentioned on sheet 2) 4a. **Are there problems with activity in location due to 'object'? What are those problems?** (per activity and location in column 2 and 3; relation problem-building must be clear; needed for POE) 5. **Do you (does your group) expect problems with activity in location due to 'object' in the future? What are those problems?** (per activity and location in column 2 and 3; relation problem-building must be clear; needed for POE) 4b. **Are there activities you (your group) want(s) to perform for state in location that are not possible there? What are those activities?** (for state and location in column 1 and 3; describe activities as impossible plus reasons in column 4; needed for POE)				
1. States	**2. Activities**	**3. Locations**	**4. Problems now**	**5. Problems future**
Physiological physical health, care	preparing meals, cooking serving food and clearing the table eating and drinking safely storing food products (& freezing) using the restroom getting in and out of bed sleaping resting, taking a nap			

A.3 Examples of Needs for Sheet 3 of the User Needs Analysis Protocol

Below is an example of general and specific known needs, for use in the third sheet, which shows how such an overview may have evolved after a series of consecutive studies. Initially, the overview is much less detailed. It is gradually built up, starting with general theoretical human needs (see Sect. 3.2.2) and extended with needs from prior studies with the protocol and other research on the group in question. In this case, it concerns needs of elderly people (with a slight need for care) who live independently or in a nursing home. The list seems rather complete and thus it can be tempting in a new project to draw up the program of demands using this overview instead of carrying out a user needs analysis. Nevertheless, it is advised to perform an analysis as experience shows that different insights are gained in each new group. As said before, this overview of known needs can also be used later in the programming and design phase to investigate whether performances and design decisions are conflicting with known needs (see Sect. 4.2.2). In the three categories of physiological, social and psychological needs, higher aggregation levels of states are in bold, followed by related activities on a lower aggregation level.

General and specific needs of elderly (with a slight need for care)

Physiological needs	
Physical health, care	
Preparing meals, cooking	Checking weight, blood pressure, etc.
Serving food and clearing the table	Checking diet
Eating and drinking	Receiving care
Safely storing food products (also freezing)	Having continuous access to care
Using restroom, going to toilet	Letting caregivers stay overnight

(continued)

(continued)

Getting in and out of bed	Ordering, storing and taking medication
Sleeping	Storing medical articles (appliances, supplies)
Resting, taking a nap	Doing exercises, therapy
(Un)dressing	Having conversations with medical professionals
Breathing healthy air	Having confidential conversations with caregivers
Cleaning the house	Receiving multidisciplinary treatments
Receiving support with medical devices (e.g. E-health and home automation)	Receiving support by means of appliances such as a patient lift, etc.
Personal hygiene	
Using restroom, going to toilet	Shaving
Going to bathroom	Grooming
Getting in and out of shower	Washing hands
Showering	Nail care
Showering while seated	Oral care, brushing teeth
Bathing	Looking in the mirror
Washing hair	Using incontinence material
Drying hair	
Household hygiene	
Cleaning the house	Disposing of garbage, waste
Tidying up the house	Storing, separating of waste
Dusting	Storing dirty laundry
Vacuuming	Doing the laundry
Cleaning windows	Drying the laundry
Cleaning up after meals	Ironing
Washing dishes	Polishing shoes
Storing food supplies	Wiping feet
Storing crockery, cutlery, etc.	Cleaning outdoor space (balcony)
Storing cleaning supplies (wipes, etc.)	Storing appliances (iron, vacuum cleaner, etc.)
Physical safety	
Moving around safely inside	Avoiding open fire
Moving around safely outside	Adjusting light for safety reasons
Preventing a fall, slipping	Finding emergency exit(s)
Avoiding obstacles, loose electrical wires, tripping	Getting help, alerting (family) caretakers, others
Preventing (injuries from) fire	(caregivers: reporting, registering incidents)
Correcting possibly unsafe situations (gas, electr.)	(caregivers: informing of unsafe situations)

(continued)

(continued)

Thermal comfort, being sheltered	
Adjusting thermostat, temperature	Not being bothered by draught
Not being bothered by heat outside	Not being bothered by damp spots
Adjusting humidity, no dry or humid air	Being able to perceive heat source
Visual comfort	
Adjusting natural, sunlight for ambience	Adjusting artificial light for ambience
Adjusting natural, sunlight for functional purposes	Adjusting artificial light for functional purposes
Seeing contrasts parts of room (e.g. door and wall)	Avoiding reflective surfaces (e.g. mirrors, floor)
Moving work to a place with more light	
Auditory comfort	
Adjusting the volume of equipment	Hearing phone
Adjusting the sound of equipment	Hearing signal of care call
Hearing own doorbell, central doorbell	Avoiding echoes
Distinguishing signals (bell, phone, care call)	Not being bothered by noise
Avoiding disturbing, unwanted noises same room	Avoiding disturbing, unwanted noises other rooms
Olfactory comfort	
Breathing healthy air	Cleaning for healthy air
Ventilating	Not being bothered by smell or bad odors
Opening windows, doors, skylights	Masking of odors
Social needs	
Direct social contact, cosiness	
Having control over (type of) interaction others	Being hospitable (food, drink, coffee with guests)
Letting in visitors	Playing joint (board) games
Receiving visitors	Organizing (joint) activities
Receiving overnight guests (grandchildren)	Organizing a party
Talking to others	Paying visits to others
Having confidential conversations	Giving or receiving help
Having fun with others	Meeting (new) contacts
Cooking together	Going outside with visitors
Engaging in joint activities	Visiting public facilities in the vicinity
Privacy (visual, auditory, spatial)	
Retreating, separating oneself from others	Having, indicating one's own territory
Finding a place of one's own for a moment	Having enough personal space
Not being seen (through windows, in rooms)	Controlling the level of interaction
Not being heard	Controlling the visibility of the private domain

(continued)

(continued)

Not being disturbed	Storing personal belongings
Resting without being disturbed	Separating oneself with visitors
Doing things without being disturbed	Letting guests to toilet without invading privacy
Intimacy	
Retreating, separating oneself	Performing sexually oriented activities
Not being heard by others	
Indirect social contact	
Using a (mobile) phone	Posting letters or parcels
Using a computer (internet, email, social media)	Receiving letters or parcels
Social, psychological support (coping)	
Experiencing help and involvement from others	Getting help to overcome loneliness
Having contact with (organizations of) caregivers	Dealing with mental health problems (referral)
Having confidential conversations	Receiving support in indirect social interaction
Receiving counseling, compassion in accepting health condition	
Psychological needs	
Feeling safe	
Having good overview situation in/around house	Having your own belongings around you
Being able to look to the outside	Recognizing the environment
Being able to see who is at the door	Recognizing caregivers
Being able to talk to who is at the door	Recognizing sounds
Checking, preventing the view into the house	Recognizing materials
Presence of social control	Selecting and supervising caregivers
Being able to alert others	Avoiding people who may be disturbed
Using the personal alarm	Reducing the risk of unsafe situations
Reducing chance unknown visitors, caregivers	
Being safe	
Locking up the house	Using the personal alarm
Protecting yourself	Avoiding wandering around
Protecting your property	(caregivers: working with another colleague)
Safely storing personal and valuable belongings	
Being relaxed, without stress	
Relaxing	Operating things intuitively (affordances)
Being, staying active	Avoiding disturbing and irrelevant stimuli

(continued)

(continued)

Having varied experiences, impressions, stimuli	Avoiding people who may be disturbed
Having a good view	Finding the toilet easily
Looking outside while seated	Drinking coffee
Looking outside while standing	Smoking
Avoiding disturbing unwanted noises from outside	Avoiding disturbing unwanted noises from inside
Sitting outside	

Entertainment, being informed, understanding

Watching tv, movies	Having a hobby
Listening to radio	Cooking as a hobby
Listening to music	Engaging in physical activities (walking, cycling)
Reading, writing (letters)	Engaging in joint activities
Fetching newspaper or mail	Participating in excursions
Using computer (internet, email, social media, etc.)	Caring of pets

Feeling at home, self expression

Furnishing the house, personification	Experiencing a pleasant ambience
Decorating the house (with small things)	Storing things for longer periods of time
Aesthetic decoration of the house	Storing things for a short while
Displaying personal possessions	Hiding (electric) cables
Expressing one's own identity with one's home	Maintaining the dwelling
Having, taking care of plants and flowers	Maintaining the garden
Customizing the layout of the house	

Self actualization

Being yourself	Playing games
Developing yourself, studying, following course	Playing joint (board) games
Having a hobby	Making valuable contributions
Cooking as a hobby	Sharing knowledge and experiences
Being creative, crafting, sewing	Participating in society
Dancing, making music	Belonging to a social group
Caring of plants	Being a member of an organization
Caring of pets	Professing a faith, religious activities
Concentrating	Displaying religious objects

Autonomy—freedom of choice, being in control

Having control over organization of one's own life	Managing personal finances

(continued)

(continued)

Having control over what is going on in the house	Keeping administration
Filling in the daily activities oneself	Archiving books, administration
Making one's own decisions with regard to care, nursing and support	Making one's own decisions about use of space

Autonomy—familiarity

Recognizing the environment	Operating things intuitively (affordances)
Having a good orientation	Adjusting the tv
Wayfinding	Reading the meter
Preserving routines and rituals	Checking the central heating, topping up
Knowing what the purpose of things is	Recognizing sounds
Knowing how to operate things, operating and controlling devices, appliances and switches	Hearing, seeing and recognizing visual and auditory signals from equipment (feedback)

Autonomy—activity, mobility, movement

Being, staying active	Maintaining the garden
Standing up and sitting down	Going to another floor, climbing stairs
Walking in the house	Going to another floor, operating an elevator
Moving at home with wheelchair, rollator, walker	Entering and leaving the house, the main building
Opening, closing doors (also the front door)	Walking along the streets
Opening, closing doors with wheelchair, walker	Shopping, taking home groceries, necessities
Operating installations, components (switches, etc.)	Visiting local services, public facilities nearby
Operating installations, components while seated	Resting along the way
Adapting (seating) heights	Using, storing a bicycle
Maintaining the dwelling	Using, parking a car
Using, storing, charging a wheelchair, rollator, walker, mobility scooter	Using (adapted) public transportation, going to the bus stop, station

Recognition, appreciation, being part of society

Receiving recognition and appreciation	Working, doing voluntary work
Participating in society	Taking care of others
Making valuable contributions	

Order, tidiness, regularity

Storing things for longer periods of time	Storing bed linen, household textiles
Storing things for a short while	Preserving routines and rituals
Putting things in cupboards, taking things out	Cleaning the house
Storing clothes, coats, shoes	Making the beds
Storing other items	Maintaining the garden

This overview is based on the following sources:

Heijs W (2010) Een programma van eisen voor de Klokkenberg: een toepassing van USE. (A program of demands for the Klokkenberg: an implementation of USE). Research report. Interface/University of Technology, Eindhoven.

Doorn van L (2012) Levensloopgeschikt wonen bij Laurentius. (Life span compatible living at Laurentius). Master Thesis. Real Estate Management and Development, University of Technology, Eindhoven.

Peeters R (2013) Zorgbehoevend zorgvastgoed? (Care property: in need of care?). Master Thesis. Real Estate Management and Development, University of Technology, Eindhoven.

Verheijen T (2015) Wonen naar behoefte. (Living as needed). Master Thesis. Real Estate Management and Development, University of Technology, Eindhoven.

Heijs W (2016) Zorgzaam wonen: een perspectiefwisseling (Living with care: a change of perspective). In: Smeets J, Heijs W, Leussink M (eds) Wonen: discoursen, praktijken, perspectieven. Bouwstenen 221. Department of the Built Environment, Universiteit of Technology, Eindhoven, pp 77–89.

Fliek J (2017) Langer zelfstandig wonen met behulp van domotica (Prolonged independent living through home automation). Master Thesis. Real Estate Management and Development, University of Technology, Eindhoven.

A.4 Instructions and Example Inventory of Performances Among Users

A.4.1 Instructions

These instructions are presented in brief. They should be elaborated in a covering letter to the respondents with an invitation to participate. These letters and the forms are handed over personally to the respondents. The instruction is discussed with them to make sure they understand it well.

A. Performances

- the list contains all user needs (activities or states) mentioned in the protocol.
- in the box under each need, the characteristics of the object should be noted that are required for that need (one characteristic per line, concise and clear).
- if this has to be in a certain location, put it in brackets after each characteristic.
- the list can be completed in own time and can optionally be discussed with others.

Indications:

- only characteristics that are necessary should be noted (but not too conservative).
- small matters can be as important as larger ones (with a brief explanation of the level of aggregation of performances with examples).
- these matters can be very precise, more global or in-between; they should be written down in as much detail as deemed necessary (with a brief explanation of the pros and cons of a solution space that is larger or smaller with examples).

B. Priorities

– this is done after all characteristics have been written down.
– next to each characteristic the importance of the combination need—characteristic
 for the design should be indicated using grades (1–10).

C. Disclaimer (to avoid false expectations)

– the intention is to take these characteristics into account, but it is no guarantee.

A.4.2 Form (Outline with Example Activities)

Cooking meals (example)
Storing things for longer periods of time (example)

A.5 Sheet for the Calculation of Functional Values and Related Measures

The box on the left serves to enter the scores for the importance of the fit (weight) and satisfaction with the fit between realized performances and user needs. It has room for 20 combinations, which should be enough for one location. If there are more, rows can be added without disrupting the calculations. The button "Clear" serves to empty the box in order to enter new scores for the next respondent. The other columns hold intermediate results for the calculations. The formulas are shown after the sheet; these can be copied in the proper places. For columns on the right, the formula for the first cell is given. These must be continued in the other cells, while adjusting the cell references. At the bottom left are: the functional value of the location, the average importance of the combinations for a location (which together indicate its priority for taking measures) and the value of the first alternative for prioritization mentioned in Sect. 4.3.2.

	A	B	C	D	E	F	G	H	I	J	K	L	M	N
1														
2			weight	Satisf				w	S'	w*S'	S' low	w high	S' & w	
3		1	1	10				1	5	5	0	0	0	
4	Clear	2	2	9				2	4	8	0	0	0	
5		3	3	8				3	3	9	0	0	0	
6		4	4	7				4	2	8	0	0	0	
7		5	5	6				5	1	5	0	0	0	
8		6	6	5				6	-1	-6	1	0	1	
9		7	7	4				7	-2	-14	1	0	1	
10		8	8	3				8	-3	-24	1	1	2	
11		9	9	2				9	-4	-36	1	1	2	
12		10	10	1				10	-5	-50	1	1	2	
13		11						0	0	0	0	0	0	
14		12						0	0	0	0	0	0	
15		13						0	0	0	0	0	0	
16		14						0	0	0	0	0	0	
17		15						0	0	0	0	0	0	
18		16						0	0	0	0	0	0	
19		17						0	0	0	0	0	0	
20		18						0	0	0	0	0	0	
21		19						0	0	0	0	0	0	
22		20						0	0	0	0	0	0	
23							sum	55	0	-95				
24		Functional value		32,7										
25											N (performances)		10	
26		Average importance		5,5						N (rows S' low & w high)			3	
27														
28		Alternative priority		30,0	(S'<0; w>7)									
29														

column w (weight)	=C3
column S' (recode of Satisf)	=IF(ISBLANK(D3)=FALSE;(IF(D3>5;D3-5;D3-6));0)
column w*S' (product)	=H3*I3
column S' low (1 if S' < 0)	=IF(I3<0;1;0)
column w high (1 if w > 7)	=IF(H3>7;1;0)
column S' & w (sum)	=K3+L3
N (performances)	=20-COUNTBLANK(C3:C22)
N (rows S' low & w high)	=COUNTIF(M3:M22;">1")
Functional value	=ROUND(((10*(J23/H23))+50);1)
Average importance	=ROUND((H23/M25);1)
Alternative priority	=ROUND(((M26/M25)*100);1)
Clear	button with macro that clears the range C3:D22

Appendix B
Questions and Assignments

This appendix consists of a number of questions and assignments that are related to the various chapters. These can be used in a teaching situation, and also in a professional context if the method appears interesting. The questions (with an open character or with multiple true–false statements) are intended to stimulate reflection and discussion. The assignments serve to practice the different parts of the method.

Questions and assignments are preferably completed in a group of 3–4 persons. This way, participants can exchange ideas, interview each other and give feedback. Completing the assignments can be a lengthy process. However, practice is more important than perfection. It is not required to have everything covered. It is advisable, though, to give attention to each assignment: therefore, it is best not to skip any, but to limit the time spent on them if needed. Answers and suggestions are included in the last part of this appendix. It is advisable to read them directly after completing the related questions or tasks.

Chapter 1

1.1.

In this chapter, the Bijlmermeer in Amsterdam is described as a formerly problematic residential environment. Another example is the Peperklip in Rotterdam. Search the Internet for global information about this complex of social housing, i.e. about the design and the location. Do not yet search for problems. The idea is that you first try to get a picture of the problems by putting yourself in the position of the tenants (hint: pay attention to the appearance of the complex and of the enclosed grounds). Describe your assumptions.

1.2.

Look at the problems the Peperklip has faced at the end of this appendix, especially with regard to the residential climate. Compare these problems with your assumptions. Indicate what you have anticipated correctly, and what you could have

W. Heijs, *User needs by Systematic Elaboration (USE)*,
https://doi.org/10.1007/978-3-031-02052-0

inferred based on the design, but did not yet notice. Also, indicate which aspects are unexpected.[1]

1.3.

Describe in what ways the so-called information gaps, and in particular the user-needs gap and the application gap, may generally play a role in the creation of these types of problems.

1.4.

What could be done to close those information gaps?

1.5.

How might a cooperation between designers and researchers (from the social sciences) in this type of large-scale projects take concrete shape?

Chapter 2

2.1.

In stage 5 in Table 2.1, an example is given of a design rule, derived from the model of information processing, which is applied to the design of an emergency exit. Establish rules for such a design that can be derived from the other stages and describe a design of an emergency exit that complies with all these rules.

2.2.

It is mentioned that there are many influential variables on both sides of the information processing model, such as characteristics of the social or physical environment, and needs, abilities and structural variables on the user side. Give examples of such variables that you could consider when designing the emergency exit.

2.3.

What affordances does your emergency exit have? How can you improve these? And how can you investigate whether the intended affordances are indeed functioning correctly?

2.4.

An affordance usually has an unconscious influence. However, if it does not have the intended effect, a conscious processing of information might occur. An example is a door with a handle that invites you to pull, while you should actually push it. Describe what happens next in terms of the information processing model.

[1] This gives an impression of the situation a designer might find him/herself in. It can be difficult to put yourself in the position of the future users, and to oversee the consequences of a design for the process of use, based on the design alone. Measures to improve the situation in the Peperklip and references for the problems and measures are given in relation to question 5.3.

2.5.

It is found that subjective fit in general is a better predictor of well-being and behavior than objective fit. How would you explain this?

2.6.

Projects in social housing are often large scale. Social design is qualified as small scale. Does this mean that there is no place for social design in large social housing projects?

2.7.

It is suggested that, in order to design well-functioning buildings, lessons can be learned from the design process of products such as computers and software, where a focus on processes of use has a long history. Yet, there are also important differences between these two design practices. Which differences do you notice in this chapter? How could you resolve them?

Chapter 3

3.1.

In a user needs analysis, what can you do to make users think about user needs in terms of personal states and activities rather than environmental elements or attributes? (for discussion).

a. This is impossible since such needs are outside their frame of reference
b. Discuss the limitations of thinking in terms of elements and attributes.
c. Ask open questions and thus give more freedom of choice
d. Derive the correct answer from their words by interpretation.
e. Show scale models.

3.2.

How can you pursue the completeness of a set of needs? (for discussion).

a. Conduct research among a wide audience.
b. Use quantitative methods with large samples.
c. Use multiple and complementary methods.
d. Use standardized lists of needs.
e. Use databases with results from previous research.

3.3.

What can you do if the users are not known? (for discussion).

a. Research similar groups of users.
b. Research a similar setting.
c. Use a database with needs of all target groups in all possible settings.
d. Then only general needs can be identified.
e. Create a flexible program of demands that is easily adaptable.

3.4.

To check your understanding of the concepts, try to indicate the nature of the next items; is it a user need (1), a performance (2) or a solution (3)?

- being able to park the car.
- a separate room for hobbies.
- artificial lighting.
- a cupboard for towels.
- safety.
- bodily warmth.
- use the phone.
- a rectangular space in the cellar 3 × 4 m.
- a programmable thermostat.
- eat and drink.
- a small fridge of brand A.
- accessibility of the building.
- type B thermostat in the living room.
- self-actualization.
- contact.
- led lamp with 3 spots of 7 W each.

3.5.

Sometimes so-called 'keep-change lists' are used as a starting point for a user needs analysis (UNA). Why is this risky?

3.6.

How can you avoid possibly unrealistic ideas in a program of demands? (for discussion).

a. By using needs on the person dimension to find performances.
b. By emphasizing activities rather than elements and attributes.
c. By defining those ideas more clearly.
d. By engaging a UNA expert.
e. By providing information in advance about what is and is not possible.

3.7.

In Chap. 2, it is said that participatory design and performance based building are possible improvements because of the involvement of users in the design process. However, these methods will probably not entirely solve some of the problems. Which problems could this be, considering the contents of Chap. 3?

3.8.

If the program of demands is limited, with only a few rough indications of areas or spaces, how can you verify that a building meets the demands in a formal sense?

3.9.

The evaluation in a design review phase, in which a program and design are discussed and checked with the users prior to construction (see Sect. 3.4), is also referred to as a pre-occupancy evaluation or an ex-ante POE. This is not covered here in detail because the format is different from that of a POE (see Sect. 4.2.3). Nevertheless, the question is whether it is conceivable to carry out a formal and a functional evaluation according to USE of the program and the preliminary design in this phase to gain more insight.

3.10.

Traditional housing satisfaction and market research is more suitable for the asset management of housing associations than USE, while USE may be more suitable for new projects or additions to the stock. Explain why this is the case.

Chapter 4

4.1.

The purpose of this first assignment is to provide a further introduction to user needs analysis according to USE, to exercise the correct formulation of user needs, and to determine the needs of a number of groups of users of a building.

- Select a building that you know because you often go there or because you are active in it, and in which people work (e.g. the building of your department; not an unknown building and not a residential building).
- Determine the user groups. Do not forget groups that are less prominent, such as technical staff or security personnel. Try to name all the relevant groups of users of the building (therefore it must be a known building).
- Assess the user needs of a number of these groups using the instrument in Sect. 4.1.3 and in Appendix A. For the interviews, you have to make an Excel sheet as in the appendix. First, perform interviews with each other as members of the user group you belong to. If you have gained enough experience with this, you can interview the members of one or two other groups (depending on the time available; normally you would interview all groups but this is not needed now). Follow the instructions carefully; they may seem complicated at first, but it becomes easier once you see the pattern (this is aimed at supplementation). In addition, pay attention to sufficient concretization. Make sure that the answers are placed in the correct rows and columns. If it is impossible to interview other group(s), you can use a role-play where members of your group represent another user group.
- Draw up an overview of the needs (the activities and overarching states) with corresponding locations for each user group. Discuss in your group the completeness of the groups, the accuracy of the formulation and the aggregation level of the needs, and the completeness of the set of needs. Use the control questions in Sect. 4.1.3. Make the necessary improvements .

4.2.

The subjects of the second assignment are a continued introduction to the program of demands in USE, an exercise of the formulation of functional demands, and the creation of a limited program of demands.

– Formulate the functional demands by linking one or more performances to each need from the previous assignment. To determine performances you can talk to the people from whom you collected the needs (possibly with the form in Appendix A) or you can base them on your common sense since you know the building. In that case, you should discuss the selection with other members of your group to avoid that it becomes too subjective. The correctness of the wording, the level of aggregation and the solution space can also be discussed in your group. Use the control questions in Sect. 4.2.1.
– Integrate the demands into a functional program of demands following the procedure that is outlined in Sect. 4.2.2. Identify potential conflicts and combination possibilities and assign priority scores to the demands.
– Check whether there already is a program of demands for your building. If so, chances are that it is drawn up in a more traditional way. Compare that program with the program you have made. Identify the differences and similarities and compare the usability of both. If there is no existing program, then evaluate the usability of your own program in your group for making a design for a new building (i.e. a design review of only the program).

4.3.

This third assignment is intended to further introduce evaluation research according to USE, to exercise a correct formulation of the questions, and to conduct a limited evaluation.

– Based on your own program of demands from the previous assignment, make a set of questions for a functional evaluation, and if possible for a formal evaluation, using the procedure in Sect. 4.3.1. Make these sets also based on an existing program, if there is one. Compare the various sets in terms of the insights they could provide.
– Make the questionnaire for a functional evaluation (and if possible for a formal evaluation) based on the sets of questions for your own program and carry out the research (note: sometimes objective measurements are sufficient in a formal evaluation). Ask a dozen users who are members of two or three user groups of the chosen building to be the respondents in your evaluation. This may include people who are not participating in the assignments. Make sure that the respondents are asked the questions for their group only. Normally, a representative sample should be used. In this case, however, experience is more important than a valid result.
– Analyze the results and, where relevant, calculate the functional values (with the last spreadsheet in Appendix A). Use the results to determine in which respects the building suffices, where interventions are needed (with priorities) and what recommendations can be given for measures to be taken (see Sect. 4.3.2).

- If there is an existing (possibly more traditional) program of demands, what information would an evaluation based on it have provided?

Chapter 5

5.1.

A lunch café for students and staff is being realized in the Department of Architecture. There was no such lunch café before. How would you carry out a user needs analysis according to USE in this situation? (Hint: like in Chap. 5, the approach may need to be adapted to the circumstances).

5.2.

Sometimes older people move to a smaller house because they feel that it can be maintained more easily, only to find out after the move that it is actually too small to store treasured belongings or to receive more than a few guests. How can you detect this fact in a post-occupancy evaluation of the new house? (Hint: here too the context can be relevant).

5.3.

The situation in the Peperklip in Rotterdam (see assignments 1.1 and 1.2) has been improved. This is the result of various measures, such as:

- repairs (installations and moisture problems).
- more daily maintenance.
- sound insulation measures.
- storage areas, porches and balconies made vandal-proof and lockable.
- availability of a place for activities.
- establishment of a women's house (for meetings and courses).
- eviction of problem tenants.
- good allocation of tenants (separation of lifestyles; similar families per porch: with children, intensive neighborhood contacts, need for privacy).
- drawing up of a mandatory cohabitation contract.
- appointment of a floor manager who is in contact with the management of the housing association.
- more supervision by the police and a security service.

How would an overview of measures according to USE be different?

References for the Peperklip:

Hazeu C, Boonstra N, Jager-Vreugdenhil M, Winsemius P (2005) Buurtinitiatieven en buurtbeleid in Nederland anno 2004: analyse van een veldonderzoek van 28 casussen. Pallas Publications, Amsterdam.

Horst ter L (2011) (T)Huis in het Anker. Een onderzoek naar de rol van sociale samenhang bij leefbaarheidproblemen op flatniveau. Master Thesis. Social Geography, Radboud University, Nijmegen.

Voordt van der T (1987) Residential crime and environmental design. The Neth J of Housing and Env Research 22: 5–27.

Chapter 6

6.1.

How can you convince designers and paying clients of the importance of research on user needs and processes of use? (for discussion).

a. By emphasizing the benefits of such knowledge.
b. By giving examples of setbacks due to a lack of alignment of a design with the process of use.
c. By using interesting theoretical models (such as P-E fit).
d. By indicating that creative freedom is not restricted.
e. By providing a thorough explanation, and using common language and terminology.

6.2.

Whether the users also take part in the actual design process is a point of discussion. Some approaches, such as participatory design, state that such participation, and the associated responsibility for the end result, is vital for design satisfaction. Other approaches, including USE, argue that the users, as experts on the process of use, should participate in all phases in which their expertise is important, but that they are not designers and that the design process should be the domain of designers. The advantages of this probably outweigh the disadvantages (see Sect. 4.2.3). The request to your group is to continue this discussion and to form an opinion on it.

A final question, which is not a part of these assignments, is whether you have suggestions for possible improvements or adjustments to USE and the underlying theoretical framework, perhaps based on your experiences in applying the method or in working on the assignments. You can send these to: wimheijs@outlook.com Thank you for your comments.

Answers and suggestions

1.1.

Your interpretation.

1.2.

Because of the shape of the complex and the hard materials, and because of a lack of formal control, there was noise pollution from undesirable activities in the galleries and the enclosed area (loitering youths). There were no facilities for young people; the youth centre had been closed down.

The size and the shape created an anonymous climate with little informal control and little sense of responsibility among the residents.

There was overdue maintenance (installations, moisture).

The housing association's allocation policy was flawed, so that families with different lifestyles were mixed together, creating irritation (families with children; people with intensive neighborhood contacts; and people who needed more privacy).

This caused a downward spiral of tenants leaving, many vacancies, and disadvantaged households moving in with a variety of cultures and without integration. It led to even less social control, more noise pollution, vandalism, drug use, insecurity and crime (in storage areas, balconies and portals), which resulted in far-reaching dilapidation.

1.3.

User-needs gap:

Exists when there is a lack of knowledge about users, processes of use and user needs, and possibly a focus on aesthetics and building technology and not on functionality.

Application gap:

Exists when designers do not have enough knowledge of the relevant social scientific research, theories and methods to obtain insight into processes of use, user needs and building functionality (e.g. through evaluation research), while, on the other hand, this knowledge is also insufficiently accessible to designers and not sufficiently specified for use in the design practice.

1.4.

Suggestions:

- More preliminary research on user needs and the process of use.
- Post occupancy evaluation to improve buildings and learn for the future.
- Outcomes that are suitable for benchmarking.
- More cooperation between disciplines.
- Improved accessibility and usability of research results, theories and methods.

USE provides insight in the process of use and the associated user needs, so that these can be taken into account in the program of demands and the design, and evaluates the functionality of buildings (i.e. in the light of the process of use), if possible in addition to the extent to which potential formal requirements are met.

1.5.

Indicate and discuss your ideas and experiences (positive and negative).

2.1.

Establishing rules: by adding 'emergency exit' to 'design elements' in the rules and then optionally making the rules more concrete as in the examples.

Design: check your personal design against the rules.

2.2

Examples:

Social context:	crowdedness (does it stand out in crowded environments?).
Physical context:	light (is it findable in the dark?).
Needs:	need for control (can it be found and opened independently?).
Abilities:	ability to walk (can it be reached by less mobile people?).
Structural variables:	age (can it be opened by children?).

2.3.

Affordances:	your interpretation.
Investigation:	with behavioral observation.

2.4.

Perception activates behavior but this turns out not to be effective. Then a new loop of the process starts with cognition (the recognition of the door as being push-able).

2.5.

See Sect. 3.4.2.

2.6.

If the focus is on aligning individual dwellings with the needs of (future) residents, social design is certainly possible. If, however, the attention is focused on the greater whole while the aforementioned alignment suffers as a result, this is not social design.

2.7.

Examples:

- Iterative cycles with continuous refinement as for products are unlikely in buildings.
- Working with personas is less feasible, because it may be less easy to depict users of buildings as archetypes (there may be more differences).

This is difficult to solve. Perhaps the use of virtual reality (such as a 3D visualization technique) with multiple (successive) designs and varying user groups is a possibility that can be considered. However, there may also be strong caveats, as the experience of a virtual interaction can be quite different from that of a real interaction.

3.1.

- This is indeed possible if the right questions are asked (see Chap. 4).
+ This is a good start.
- This does not change anything.
- This is often impossible and may lead to a subjective bias caused by the researcher.
- This is not a good idea; they represent the environmental side, not personal needs.

3.2.

+/− This can help if all user groups are included.
+/− This can help if the samples are representative of all user groups
+/− This can help, but it depends on the type of methods and the sample whether
 it can be done.
− No, there may be specific needs of certain groups in certain situations that
 have to be taken into account as well.
+/− This can help if the databases contain data on the same types of objects and
 groups.

3.3.

− The object and the setting should also be similar.
− The object and the user groups should also be similar.
+/− That would help, but the existence of such a database is unlikely.
− If the object, the setting and the groups are similar, more specific needs can
 also be determined.
− It is not easy to determine in which respects the program should be flexible,
 and a program that meets as many situations as possible is likely to be too
 general.

3.4.

1 - 2 - 2 - 2 - 1/2 (it is a transactional quality) - 1 - 1 - 3 - 2 - 1 - 2/3 (depending on the
solution space: the number of small brand A fridges) - 2 - 3 - 1 - 1 - 2/3 (depending
on the solution space); sometimes discussion is possible

3.5.

They emphasize the environmental rather than the personal dimension.

3.6.

+ These needs guide the search for suitable performances, and can serve as a
 frame of reference for assessing their realistic nature, among other things
− This statement relates more to a user needs analysis
− They can still be unrealistic
− This requires an expert in the field of performances such as a designer
− Prior to a search for performances this is too restrictive, so innovative ideas
 might be obstructed; afterwards this is possible (and indeed should be done)

3.7.

Examples:

− Participating user groups are often restricted to those involved in core activities.
− Some instruments to register user needs (e.g. keep-change lists as in question 3.5)
 may take the status quo as a starting-point, thereby emphasizing the environmental
 dimension and possibly familiar solutions.

– There may not be an analysis of user needs on the person dimension, so these needs are not available as a basis or guide to search performances. This may impede on the quality and comprehensiveness of a program of demands.

3.8.

– One can settle for a formal evaluation of the presence and sizes of those spaces.
– Often such a program is incomplete, not only in terms of formal requirements but also in terms of the user groups taken into account. To improve this, only a post-hoc user needs analysis among all groups can be a solution, followed by the preparation of a complete program of demands. This is more suitable for both present and future evaluations, but it takes more time and is more expensive (please note that a special program is only suitable for a functional evaluation and not for a formal evaluation; see also Sect. 4.3.1).

3.9.

If there is a suitable program of demands, then a formal evaluation can be carried out. However, a program of demands can still change; this is possible up to and including the construction phase (see Sect. 3.3 and Sect. 4.2.3). Then, the validity of the outcomes may decrease. This also applies to a functional evaluation. It is possible, but the results will depend on experiences with a building that does not yet exist. For example, one could use virtual reality (3D visualization tools) to simulate these experiences, but there is a chance that future actual experiences will deviate from that.

3.10.

Asset management is about the future-oriented matching of a stock to the market and identifying discrepancies (e.g. in size, type or price). It does not immediately involve a program of demands or a design at building level. That is usually relevant in a new project or for additions to the stock, so USE is more appropriate there.

4.1, 4.2, 4.3.

Check your answers using the information in Sect. 4.1, Sect. 4.2 and Sect. 4.3 respectively.

5.1.

There are two groups of guests: students and staff. Possible other groups are: the café staff, the suppliers, the cleaning service, the technical service, security, management and people with visual or mobility impairments. However, the staff and the suppliers do not yet exist and the other groups do not have experience with a lunch café at that location. Therefore, a user needs analysis will mainly yield assumptions, which may be based on experiences elsewhere. To obtain a valid overview of needs, it is advised to also carry out a user needs analysis among these groups in a similar type of lunch café at a similar location and combine the results, whereby well-considered decisions must be made regarding possible differences. This is comparable to the strategy in the first example in Chap. 5 concerning apartments for the elderly.

5.2.

First, it must be established whether the new house is indeed smaller but not too small in view of the demands (and thus no mistake has been made that could also explain a negative opinion). This can be done by comparing the number of m^2 and/or rooms in the new and the former dwelling, possibly as a part of a formal evaluation. Then, in a functional evaluation, performances regarding size can be linked to the user needs of 'maintaining', 'storing treasured belongings' and 'receiving guests' (with satisfaction and importance scores).

A possible problem is social desirability. Older people may be inclined to assess their situation more positively than it is experienced. This problem may be less pronounced if the questions are not about their satisfaction with the dwelling as a whole but about satisfaction with smaller and more concrete aspects (using the needs). Nevertheless, a good instruction is needed, pointing out the anonymous character of the answers, but even then, the problem can be persistent.

5.3.

Possible differences:

- Specification of the user needs involved, as motives that can clarify the measures (in accordance with the format of functional demands; see Sect. 3.3.2)
- More detailed information, such as aggregation levels, solution spaces, locations and the user groups concerned
- Identification of possible conflicts and combinations of measures
- More measures. Because USE provides a thorough (and possibly more complete) overview of needs and demands, that can serve as a basis for an evaluation, there is probably more insight in the problems that are related to the process of use, also the less conspicuous ones.

6.1.

+ By pointing out, among other things, the potential for a better program of demands and design, more satisfaction and well-being among the users, appreciation for and confidence in the designer, less failure costs and a longer functional life, and a low risk because of the modest investment compared to possible failure costs later

+ For example by comparing projects with and without a proper user needs analysis

+/– This can be useful, but designers might be less interested in theoretical models

+/– This may apply to some designers who have this fear

+ A clear communication helps, for example through comprehensible definitions, a good explanation of the dimensions and the difference between needs and wants, and a clarification of the method.

6.2.

No suggestions.

Appendix C
Application of USE in Problem Neighborhoods

This appendix contains some thoughts on the application of the method in the renovation of problem neighborhoods in larger cities. The application can take the form of a renovation with a pre- and post measurement, that is based on a special program and problem-oriented demands (see Sect. 5.3). The possibilities are described with this type of application in mind.

Most large cities in the Netherlands have neighborhoods characterized by a low quality of the built environment and services, and serious economic and social problems. A relatively large part of the population has a lower level of education and a low income. There is substantial unemployment and more crime. Although redevelopment plans for these neighborhoods yielded some results, there were still 38 so-called 'aandachtswijken' (or attention areas) in 2018. Residents are not satisfied with the effects of the measures on safety, integration, social cohesion and services. Some of the problems seem to have transferred to neighboring areas (referred to as a waterbed effect). It would be interesting to examine whether and to what extent a functional approach, such as USE, can contribute to solving the problems in these neighborhoods. More in particular, the method may be useful with respect to the following issues:

- the low number of participating residents.
- a lesser involvement of residents on a higher, strategic level.
- the diversity of problems.
- differences of opinion regarding environmental quality.

A low number of participating residents

On average, the degree of resident participation in these neighborhoods is low. This may be the result of a lack of motivation or a certain distrust in local governments, because sometimes plans are made without consulting residents and authorities do not live up to their agreements. Residents are often not very familiar with the opportunities to participate, due to a lack of information or a limited understanding of the

W. Heijs, *User needs by Systematic Elaboration (USE)*, https://doi.org/10.1007/978-3-031-02052-0

language. Because of the circumstances, residents may have priorities that do not match an active involvement (e.g. worries about unemployment, income or illness). Most people in these neighborhoods are not very organized. Individual persons may be reluctant to express their wants or they may assume that personal requests will not be granted. The workload of participation activities can lead to a self-selection of *professional* participants who are usually older and have a higher level of education and a higher socio-economic status. There are doubts regarding the ability of this group to offer information on the problems and needs of other groups in the neighborhood.

Experiences with USE indicate that this method raises the motivation of users. The protocol for establishing user needs connects to their everyday life and addresses people on their own cognitive level. Talking about the actual activities, states and problems makes participants feel that they are being listened to, which enhances their faith in a successful outcome and lessens distrust. Specific (abstract, technical or digital) knowledge is not required and the method can be adapted to the language and situation of residents (e.g. to ethnic minorities). People can actively and individually be given an opportunity to participate; involvement is not dependent on their own initiative or on the membership of an organization. A personal invitation provides more control over the representativeness of the group and the number of professional participants.

A lesser involvement on a strategic level

The livability of these neighborhoods is improved by small-scale projects focused on topics such as social control, safety, integration, responsibility of residents for local green areas, education, sporting activities, etc. On this lower level, residents are participating in all stages, from problem definition to execution and management. However, on a higher strategic level the situation is different. This level concerns renovation projects for the entire neighborhood, with many stakeholders and large investments. While citizen participation was meant to be an interactive process on all levels, many cities and housing associations seem reluctant to engage the residents in renovation plans. Their importance as neighborhood experts is recognized in small-scale projects, but participation on a strategic level is seen as time-consuming and a potential threat to institutional interests. Consequently, starting covenants are prepared without the residents and their input is restricted to information gatherings and public hearings. In these meetings, their contribution primarily consists of criticism (e.g. on demolition, forced removal and the pace of the process). The response of authorities and the information that is given in return may cause residents to feel that they are not taken seriously. This can easily become a vicious circle, deflecting the attention from potentially useful alternatives that can be suggested by residents.

Instead of excluding a more extensive participation in larger renovation projects, one can actually try to engage residents in stages in which their contribution can be valuable, and avoid activities that are too complicated to prevent unnecessary risks. The procedure recommended in USE seems to allow for this. Residents are the foremost experts regarding everyday activities, problems in the neighborhood, and locations that are related to those activities and problems. They have certain

practice-based opinions on how to facilitate activities and solve problems. Residents generally do not possess the knowledge or skills of planners and designers but they are perfectly capable of judging whether the plans fit their ideas. To employ their expertise more efficiently, residents can be systematically involved in the analysis of needs and problems, in searching suitable performances (with the assistance of professionals to establish the appropriate levels of aggregation and solution spaces), and in the feedback and discussion in a design review. In doing so, residents can make meaningful contributions to problem-oriented programs of demands and designs, even if they are not involved in activities that require specialized knowledge such as the planning and design of complex projects.

The procedure increases the probability of realizing acceptable plans. The solution spaces of the performances in the demands extend the options to create suitable and matching alternatives. Unacceptable decisions are less likely since the designers and planners are not only aware of the solution spaces but also of the motives of the residents (the related needs). Even if a solution deviates from a solution space, the chances of it being accepted are higher if the residents can see that it facilitates the activities and states (the needs) in question. In addition, feedback and discussion in the design review provide the opportunity to clarify ideas that may have been falsely understood and to suggest corrections or alternatives. By staying close to the everyday experiences of residents, utilizing existing knowledge at the appropriate moments and avoiding unfamiliar or demanding assignments, the procedure prevents frustration and a loss of time, whereas the level of support is enhanced and the plans may be improved.

The diversity of problems

The quality of the analysis of neighborhood problems is vital for the rest of the process. These problems can vary greatly in terms of content, size, scale and their physical, economic, political, social and cultural contexts, and there may be disagreement on those issues. Moreover, problems are seldom isolated entities. They are linked to other problems and they will influence each other. Because of this diversity, it is not surprising that a description of problems and their interrelationships in research reports is sometimes incomplete. The form of the information may also vary, from detailed accounts of individual events to summaries of incidents in a free format or lists with preferred solutions. This can obstruct the making of a proper diagnosis and the setting up of an effective intervention strategy.

In the user needs analysis protocol for the special program, the problems and their connections with activities, states and locations in the cognitive structure are systematically probed. This results in a more complete view of the problems. The cognitive structure offers a better understanding of the relations between problems and of the links with influencing factors. Each problem can be provided with the same types of information about the associated user needs, locations and environmental aspects, and about related problems in a spatial, functional or administrative sense. This can be a first step towards some kind of standard format for a formulation of diagnoses and measures that consistently covers all relevant data.

Differences of opinion regarding environmental quality

The government aims to improve the environmental quality of these areas of attention. There are many quality indicators such as the unemployment rate, the amount of services or crime, and indices such as livability or the quality of life. The debate on problems and the necessary interventions is sometimes held up by differences of opinion among authorities, designers and residents on how environmental quality is to be understood, and what seems to be required to accomplish that quality. Some local governments, for example, focus on the physical quality as a basis for economic welfare and social cohesion. This is to be achieved by demolishing and rebuilding houses with the forced relocation of part of the population as a side effect. The residents, on the other hand, have a psychological attachment to their neighborhood. It is a part of their identity. They prefer to stay and to have their houses and the environment improved.

There seems to be a need for a measure of environmental quality in which more account is taken of the perspectives of residents and which includes the physiological, social and psychological aspects of the interaction with the environment. The functional value, as explained in Sect. 3.4.2, can be an alternative measure for environmental quality. It is based on satisfaction with the fit between environmental resources and the physical, social and psychological needs of the residents and on the perceived importance of that fit. This functional value can reflect the quality of the separate parts (streets, blocks or smaller vicinities) or of a neighborhood as a whole. Its composition can uncover the elements that are critical in the renovation process. By comparing present values with those after the completion of a project, it is possible to judge whether progress is being made. Taking this one step further, it could be feasible to calculate scores based on the perspectives of designers and residents and to examine the differences as input for a discussion on the measures that were taken or that may still be required. The quantitative nature of the functional values and their clear substantiation can be an impulse for more consensus and progress.

Index